Death By The Digits
by
Allin KHG

2012
KHG InterServ
Oklahoma City, OK
empallin@yahoo.com

For Sara

An Unsteady But Stable Constant

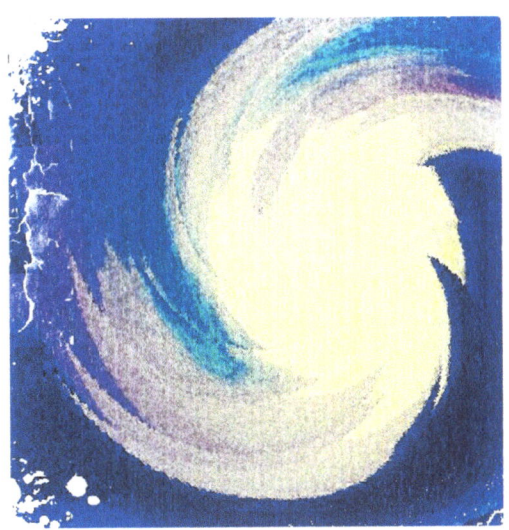

A Quick Introduction

The images included here are modifications of pictures I took with my phone of the television as I was trying to go to sleep. It just happened during a period where sleep eluded me and solitude was the last thing I wanted. The titles relate to the particular show the picture was of. Seems nothing helps my bad moods like shows about death and destruction.

Once I had a picture, I would load it into various photo editing applications on my phone. Tweaking and playing with each image until it ended up as something I liked. Each image took an average of 45 minutes to complete. I did not have any real finishing point for any of them other than what looked right to me. It was really just something to fill the time and try to distract myself until I finally passed out, hopefully finishing each one before the show ended.

Now I present these images to you with the hope that you enjoy them much more than I enjoyed the time used to create them. Though I did not enjoy the time, I am satisfied to see that something pleasant came out of it. Even though I was teaching myself a new method with new technology I feel that each piece included is fully presentable.

Due to the method of creation the blurring and pixelization in some of the images should be considered part of the piece. It is not supposed to be or not be there. It simply is, like brush strokes in a painting.

Thanks to: Pandora Warren, Deviantart.com, Instagram.com, Stephanie Ruggles Winter, Cliff Evans, Sandra Alhilo, Steve Luc, Amy Womack and you.

Thanks to Sara Young and Leonard Bishop for editorial assistance.

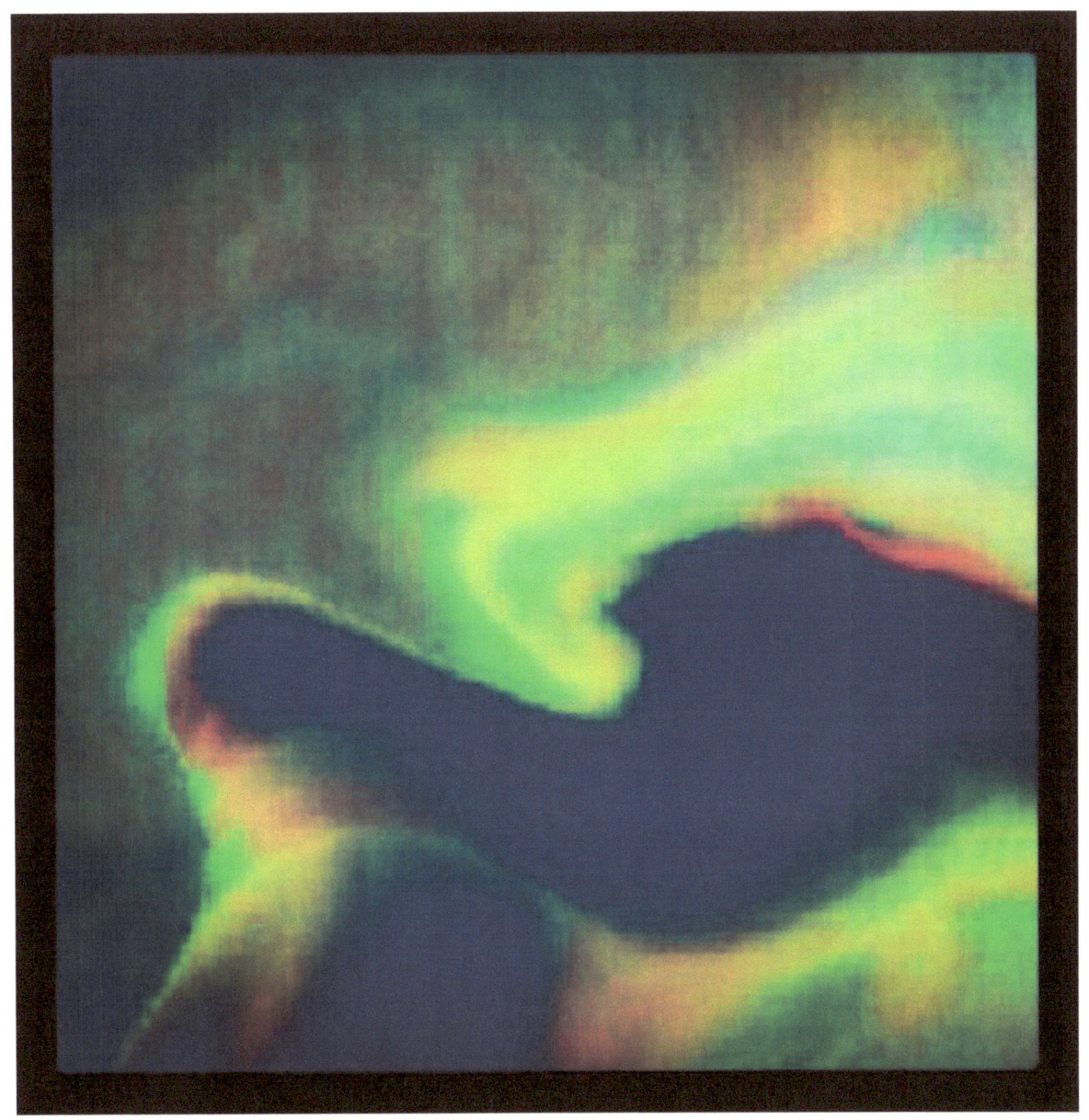

It wasn't going to be easy but it was going to happen no matter what.

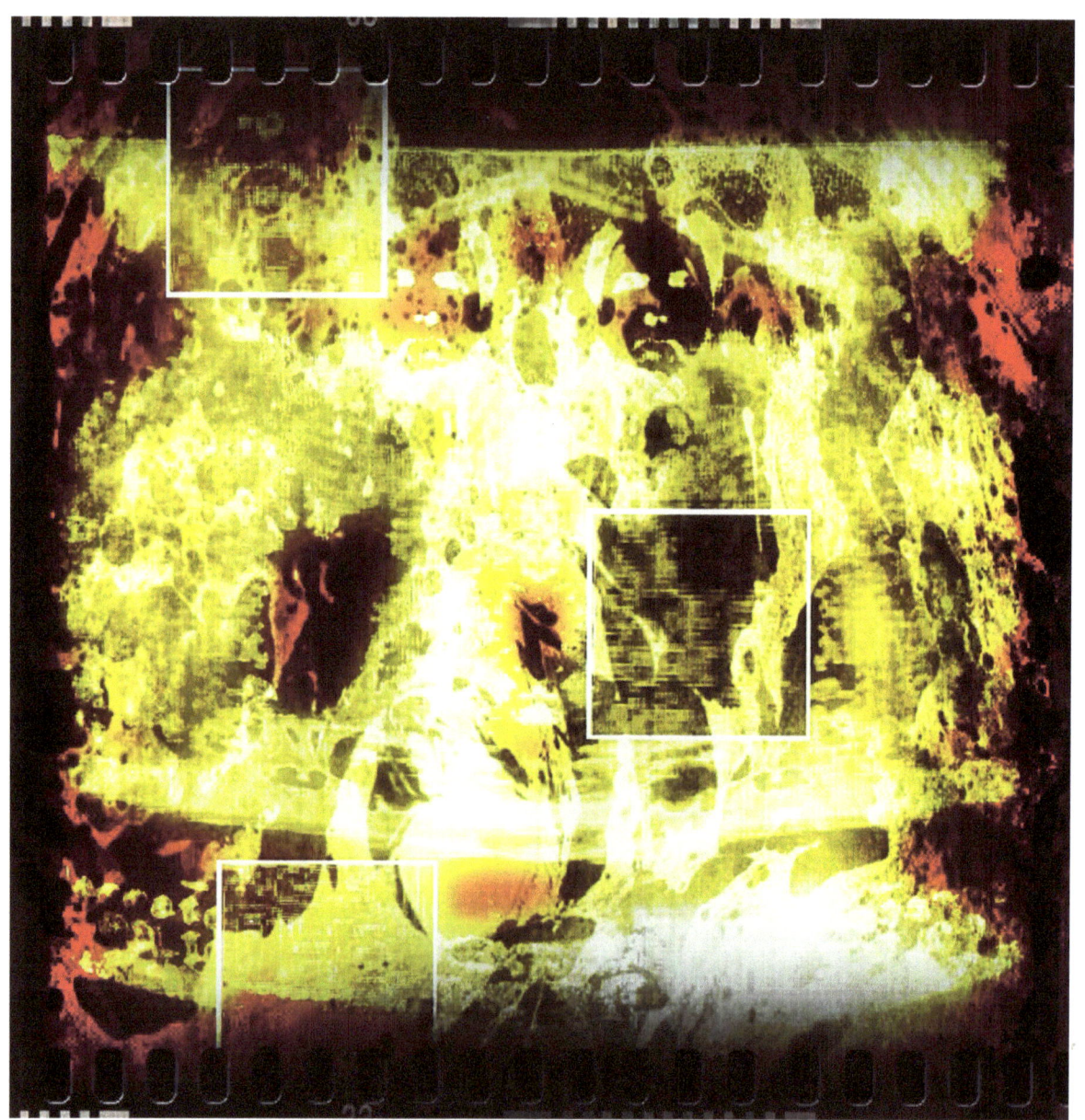

The job was just looking and watching until the time came to make a move.

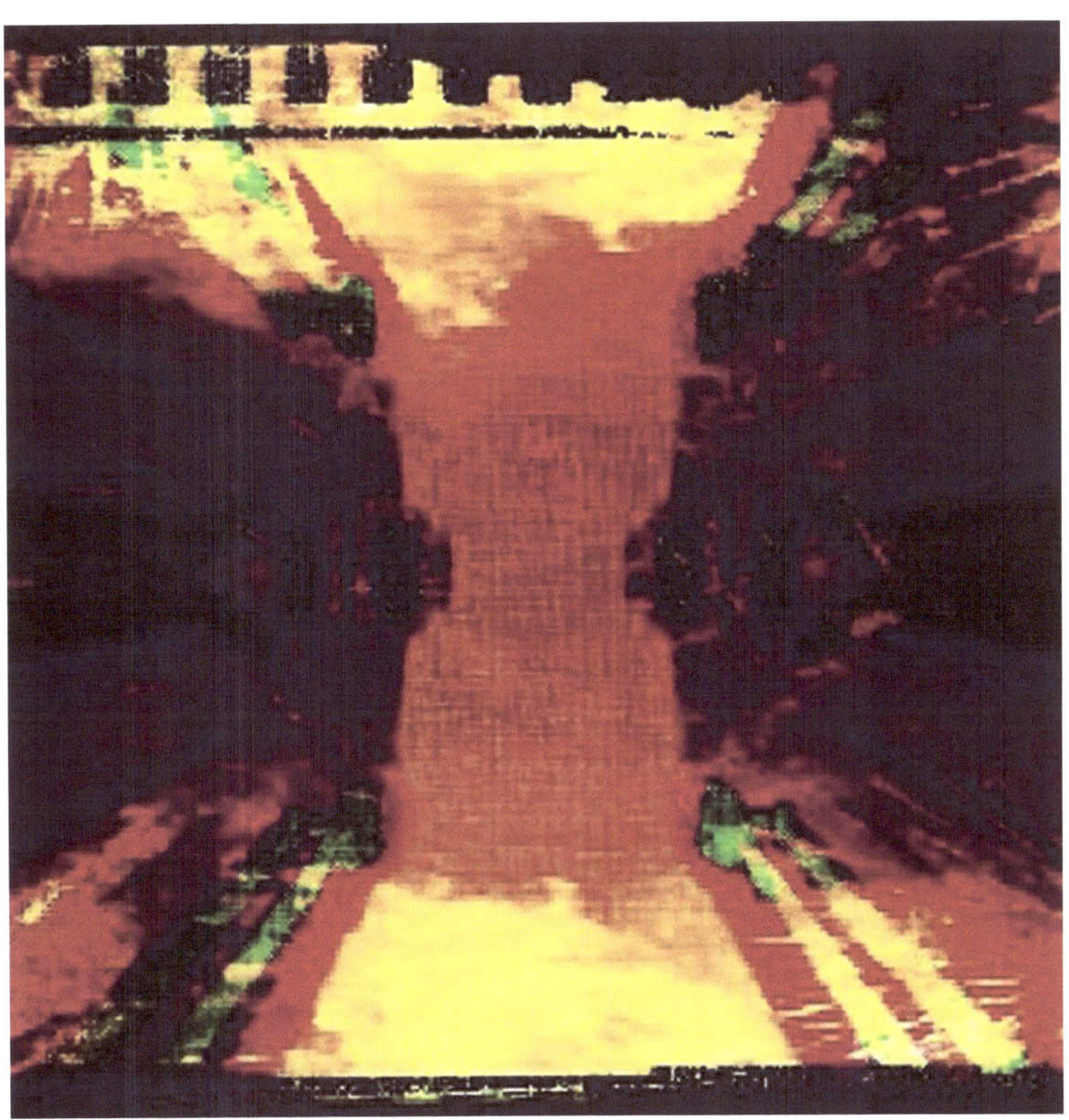

Sometimes you can't just forget it and walk away.

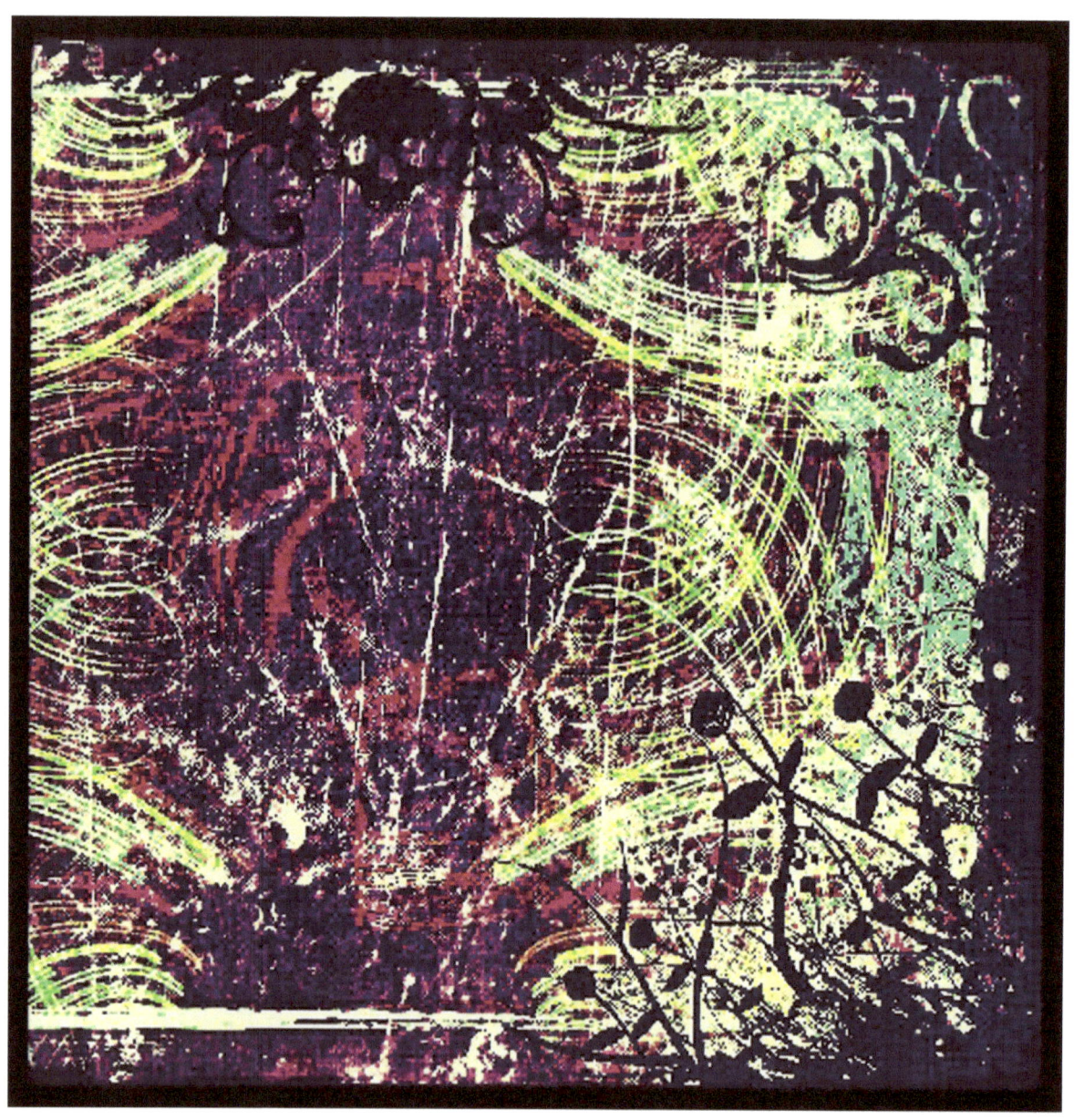

It is the ones we love the most that are able to cause us the most pain.

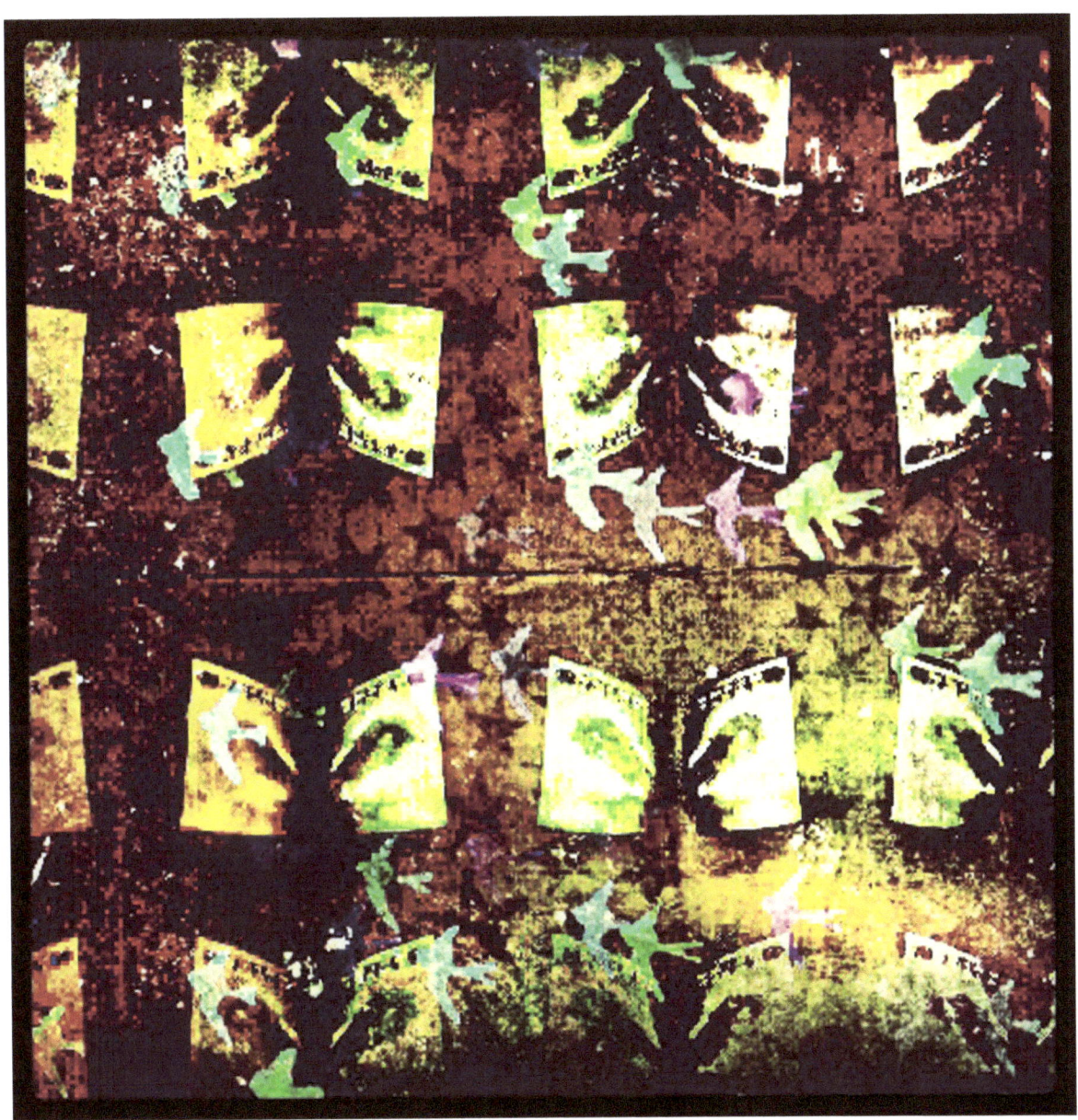

Faulty but still fuctional as to be of use.

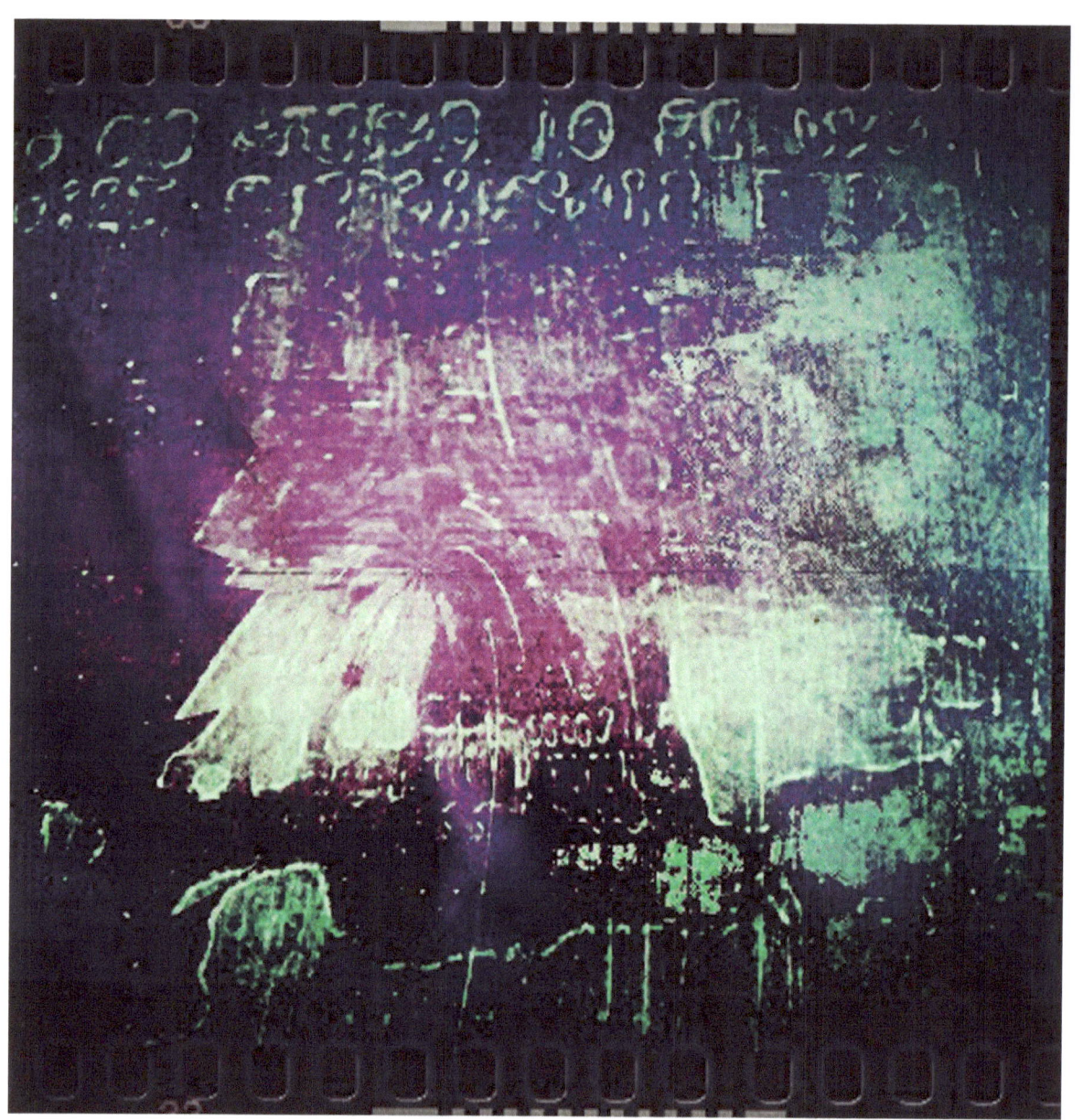

She did everything she could think of to kill him.

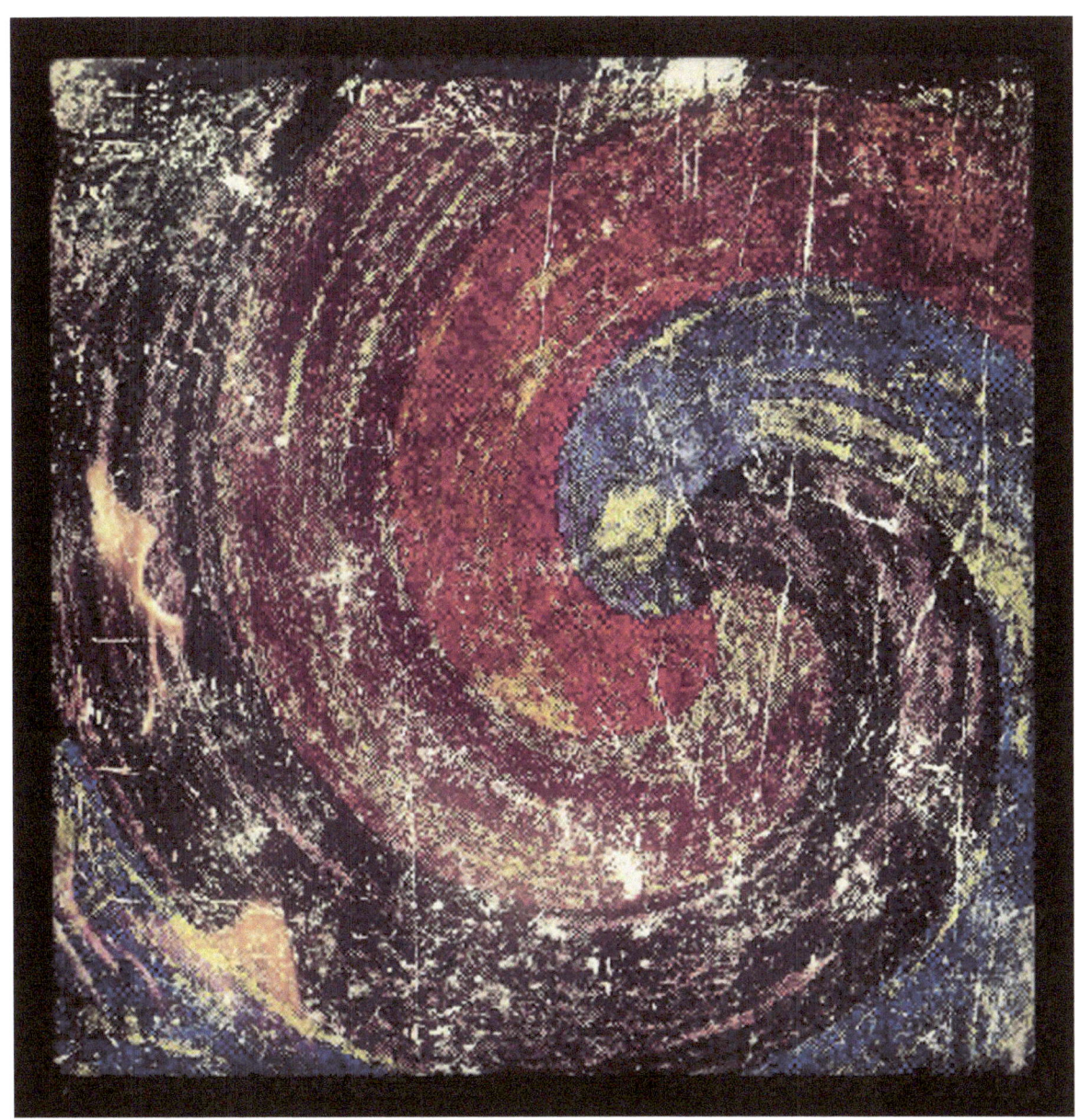

He couldn't even pretend he cared.

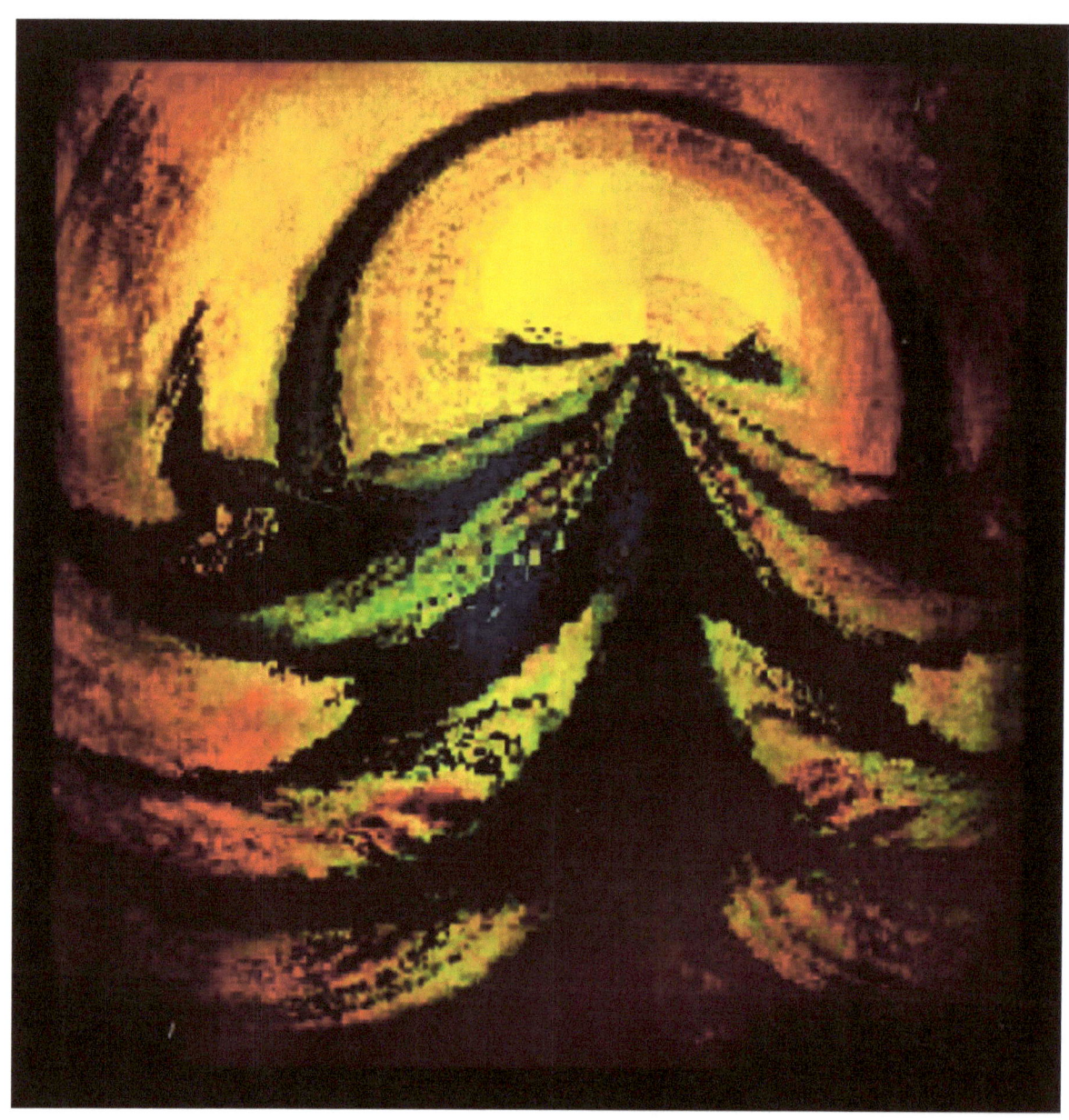

It was a lot of work to get done alone.

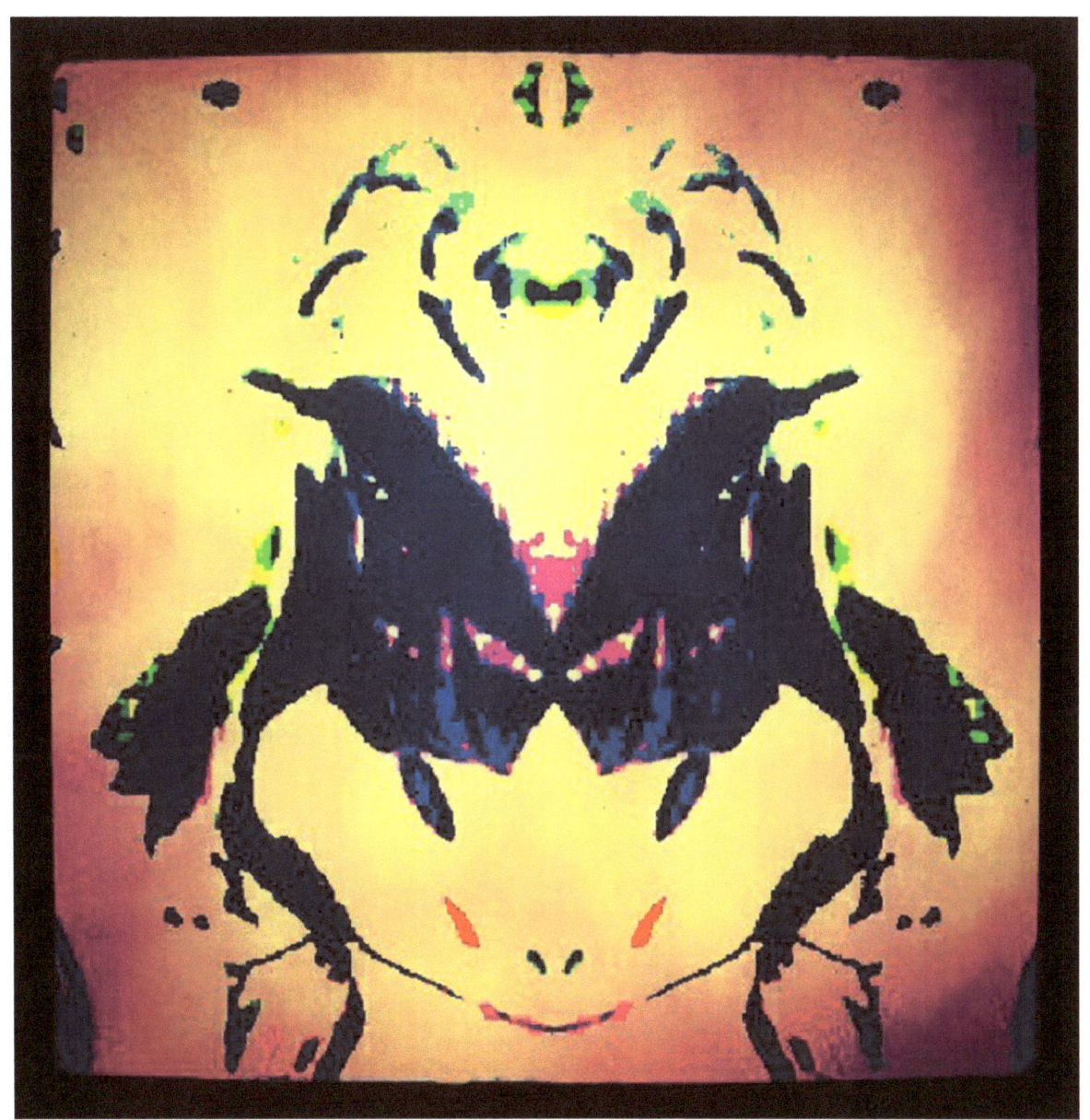

She wanted to be there but should have been anywhere else.

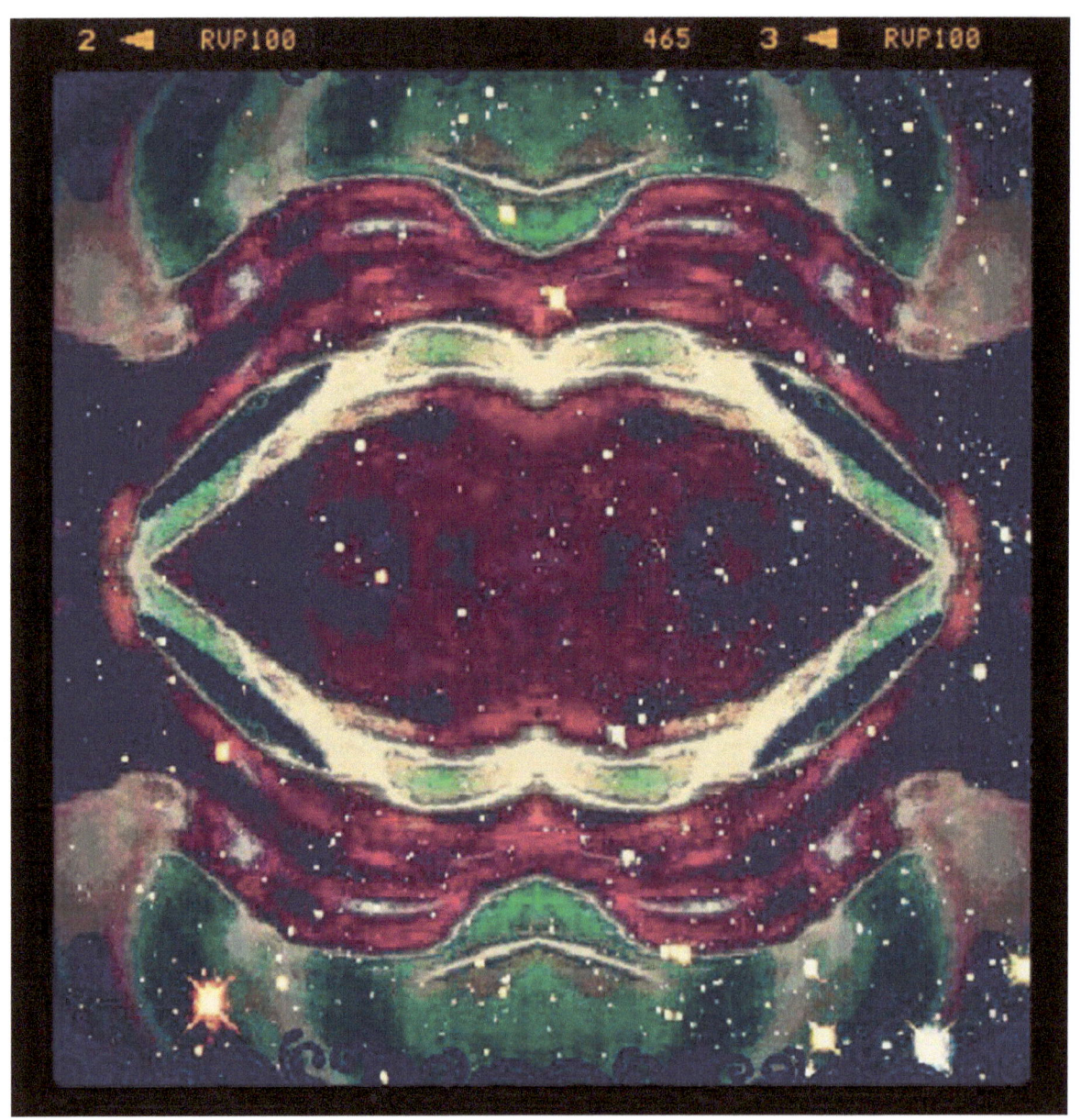

Saving him was just what she felt was just.

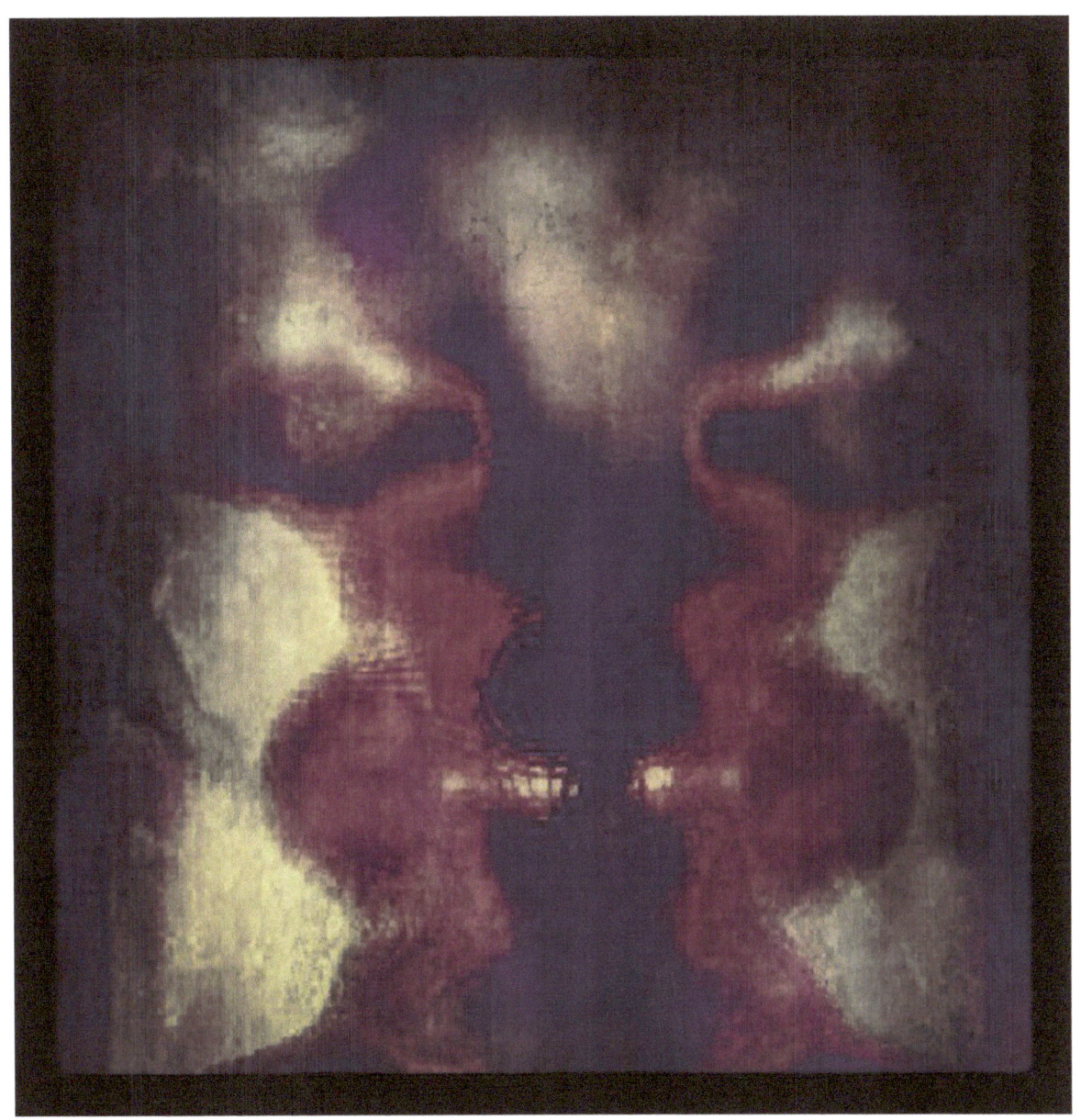

She realized he wasn't the type of man she wanted to be with.

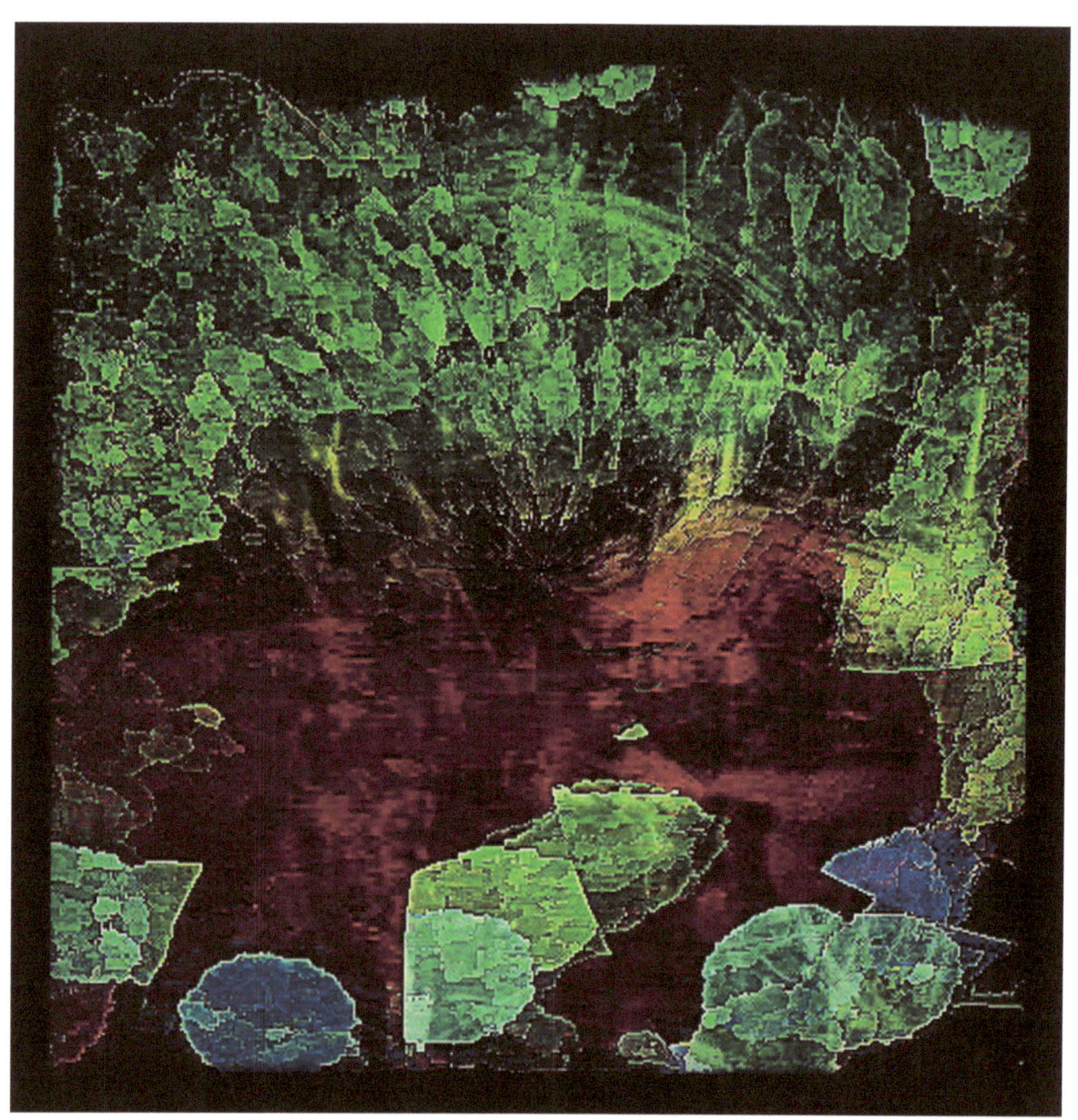

She thought status and sexual satisfaction would justify everything.

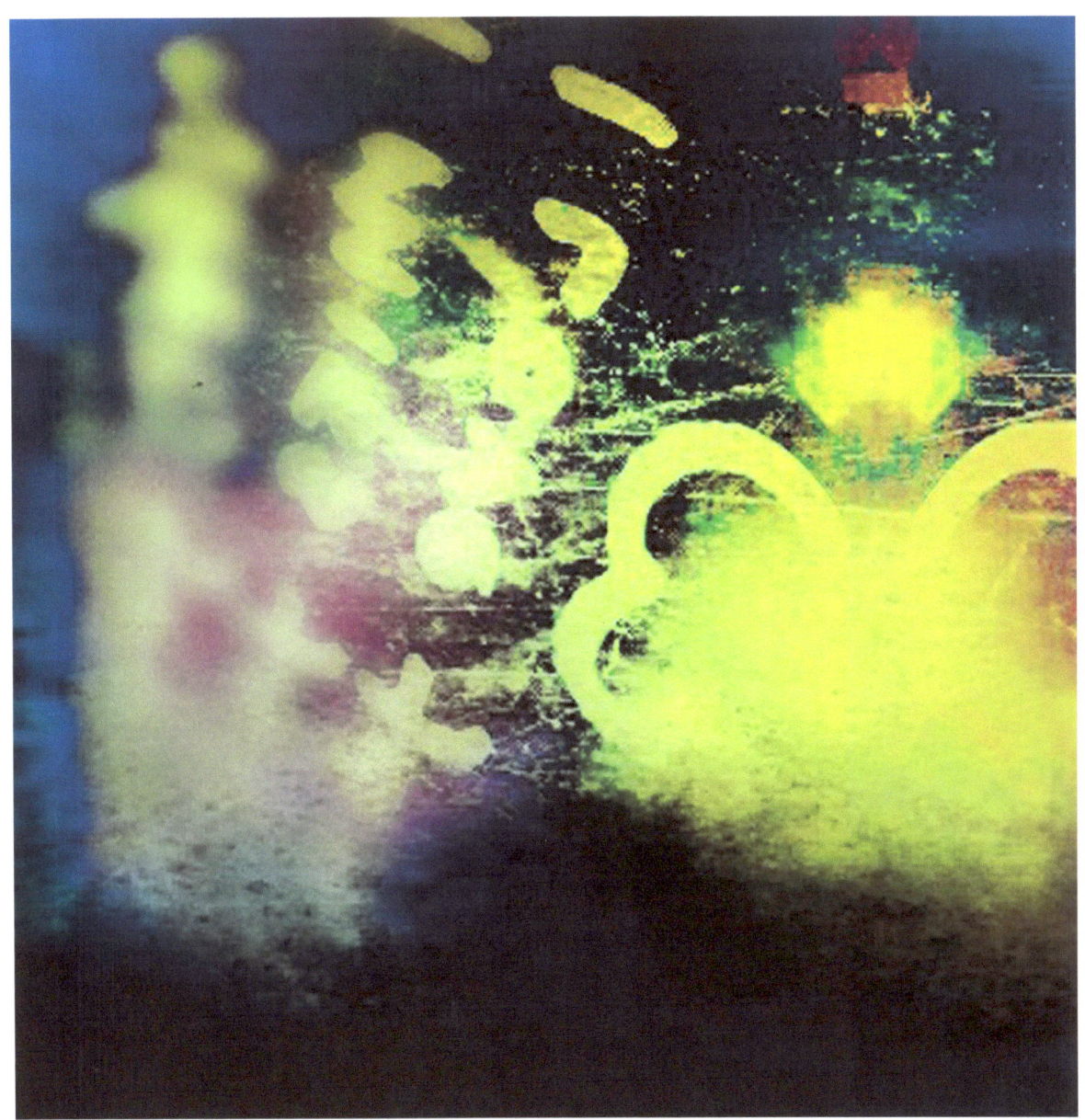

It was just too much to be able to deal with.

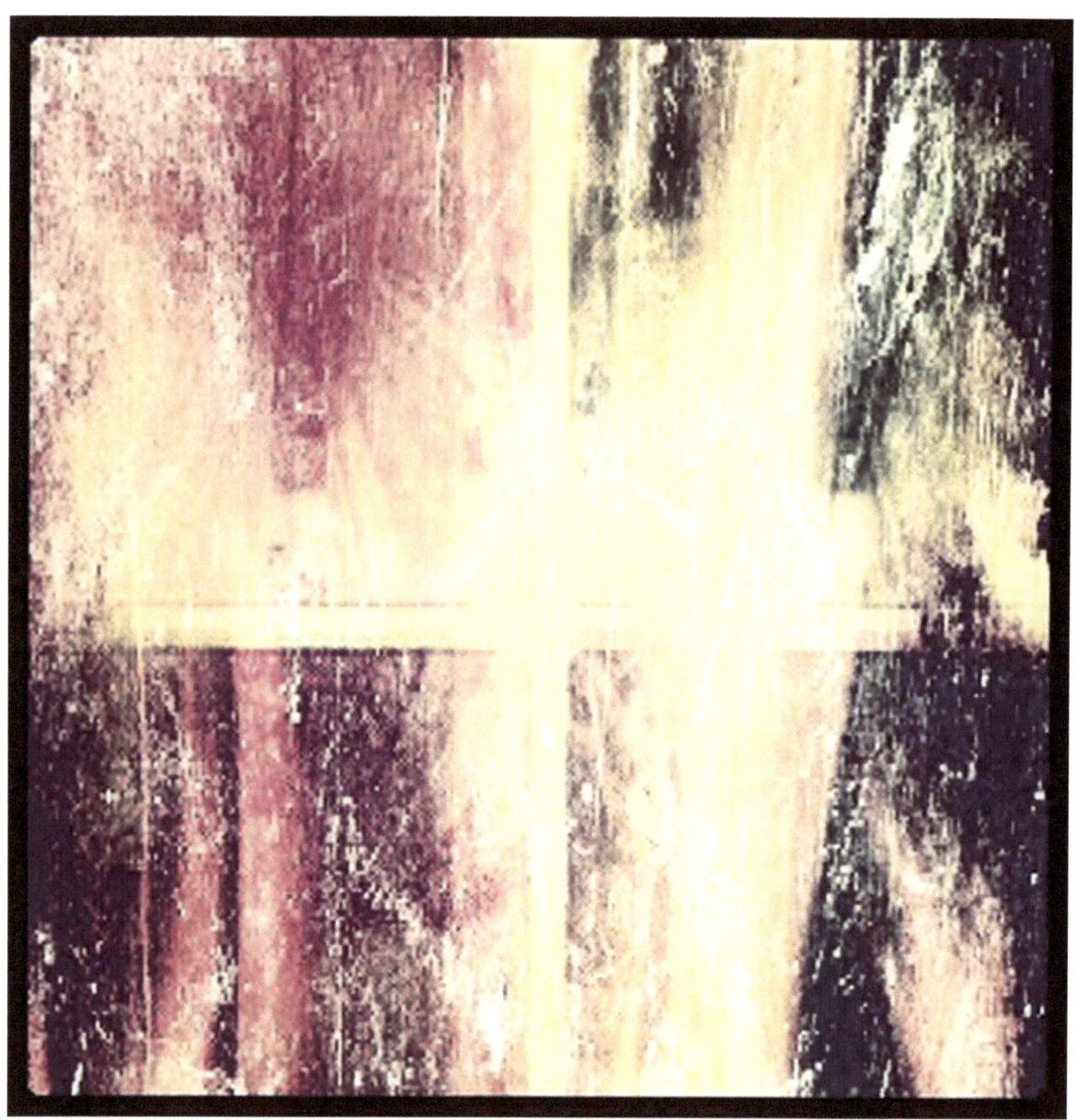

After everything that happened between them he still loves her like no other.

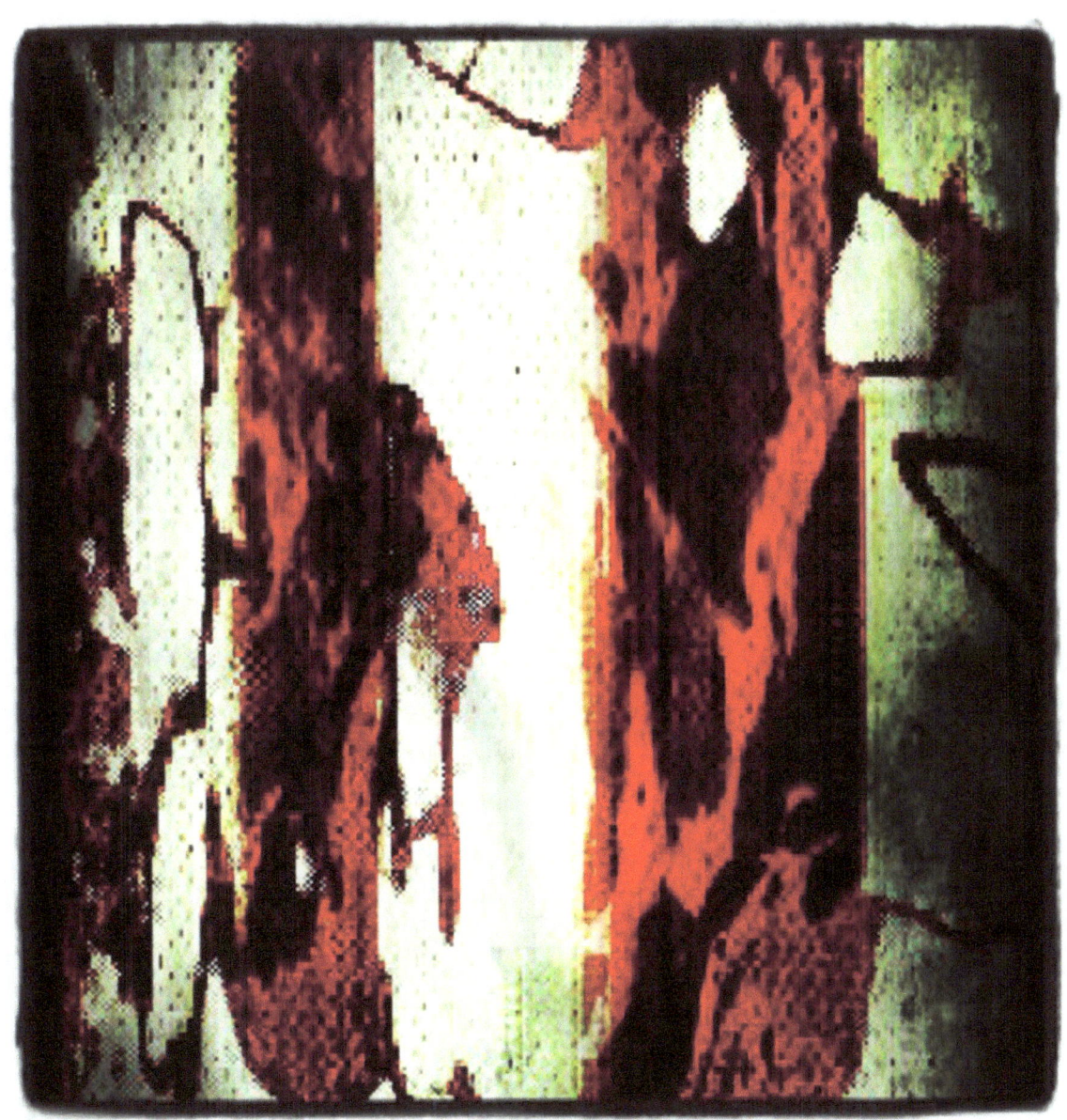

There was blood in every possible spatter pattern but they dropped the charges against her.

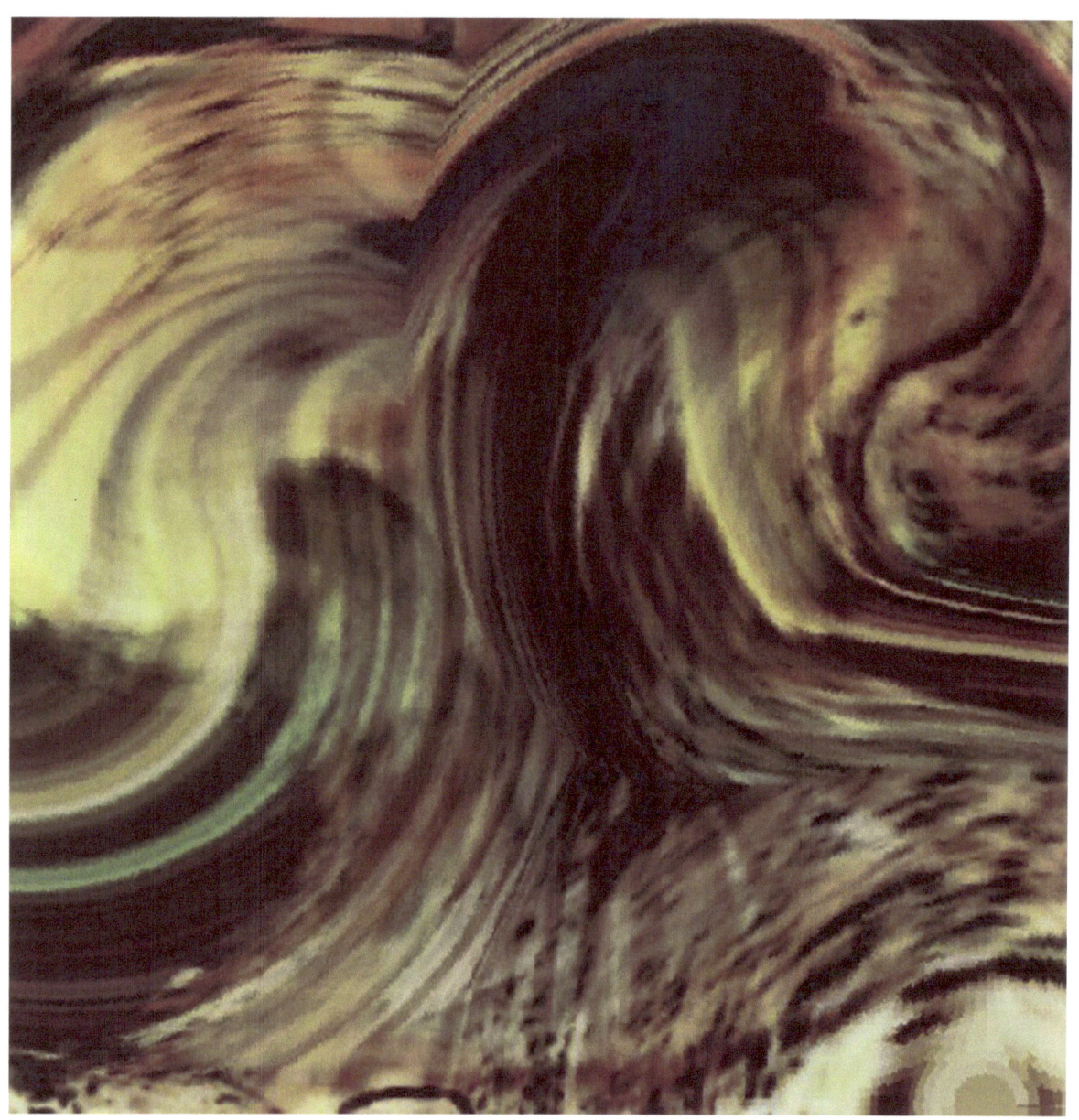

How could you not notice facts like that?

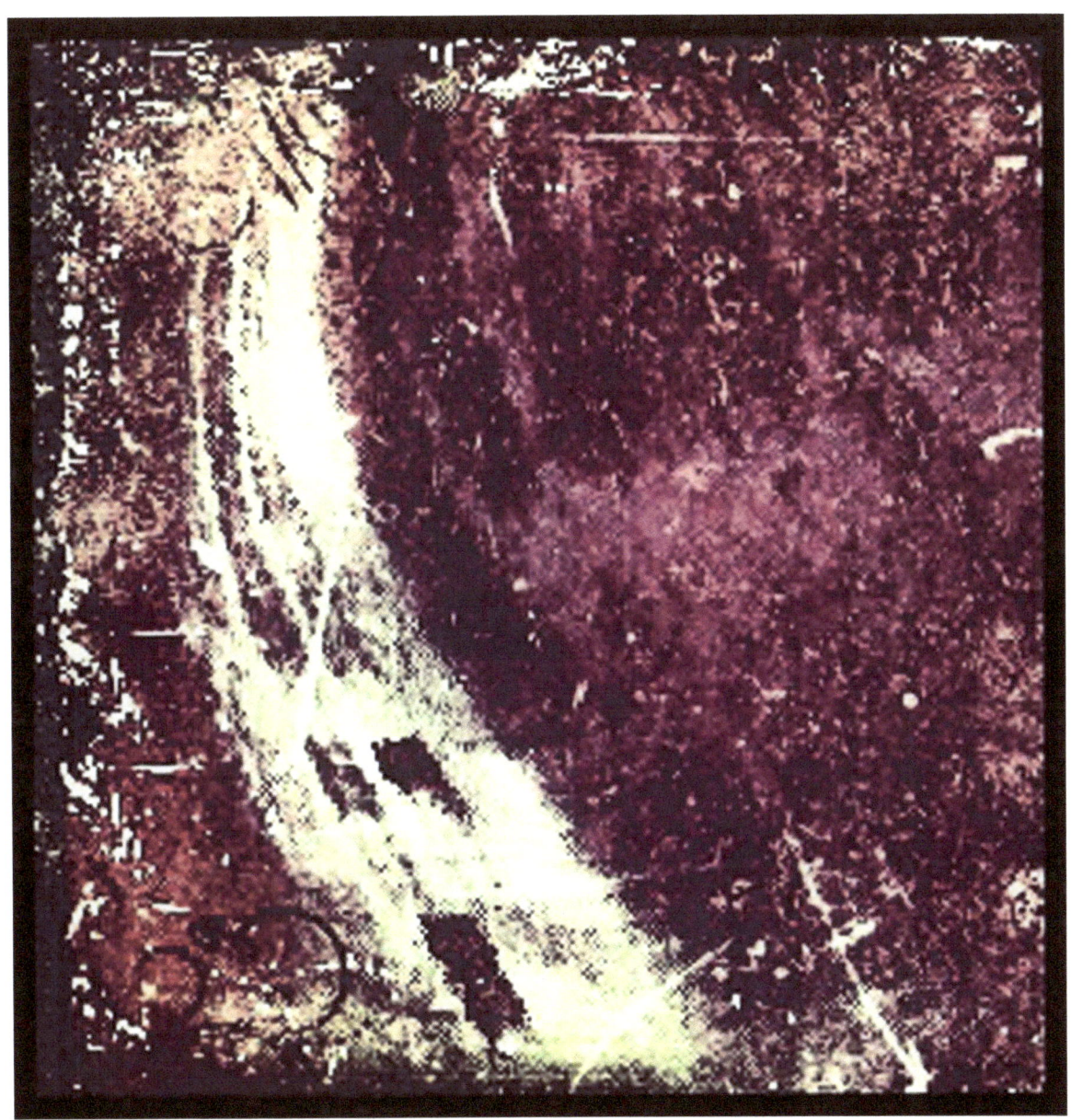

He lashed out because he couldn't say what he really felt.

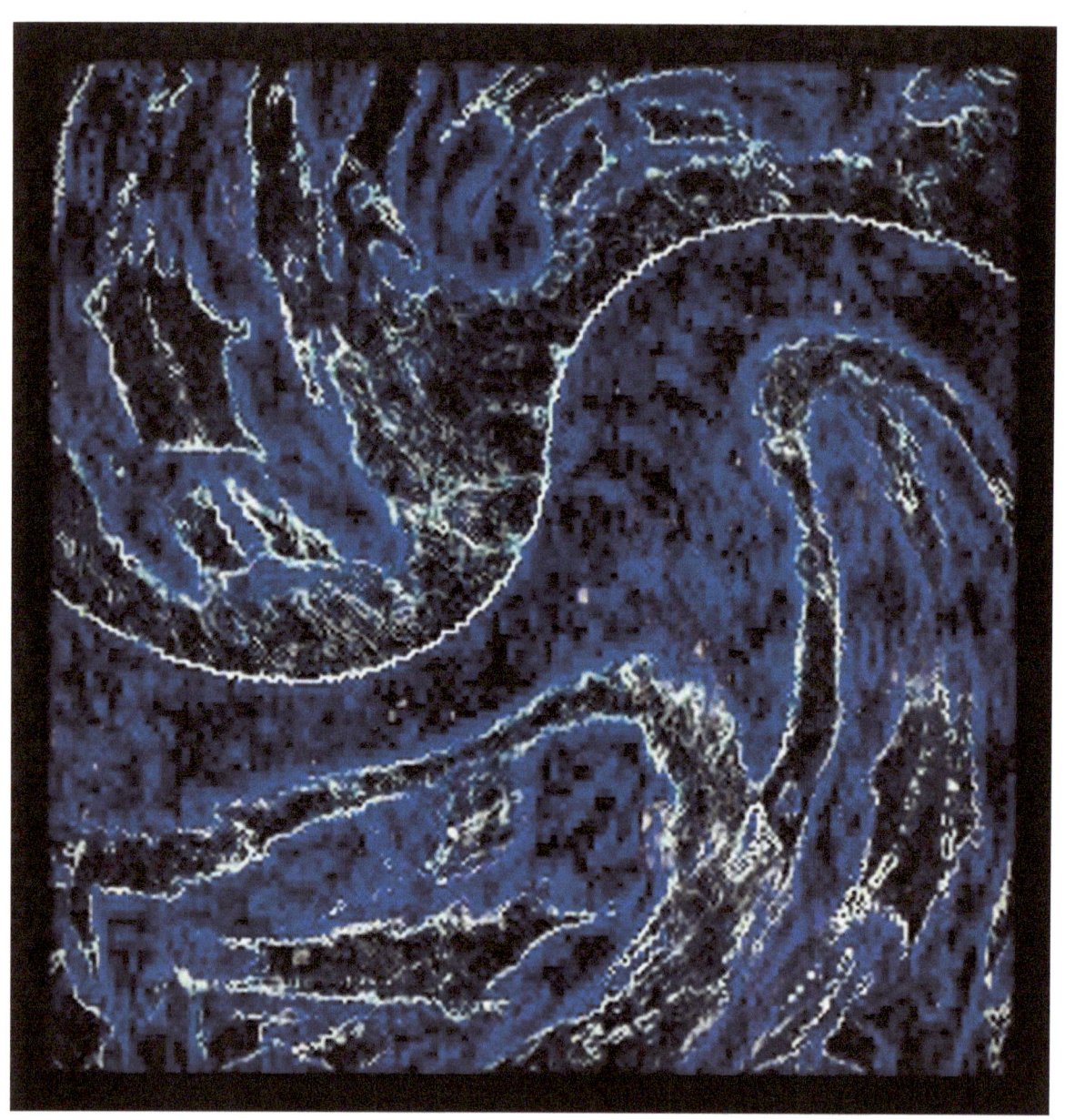

She will never know how much she is missed.

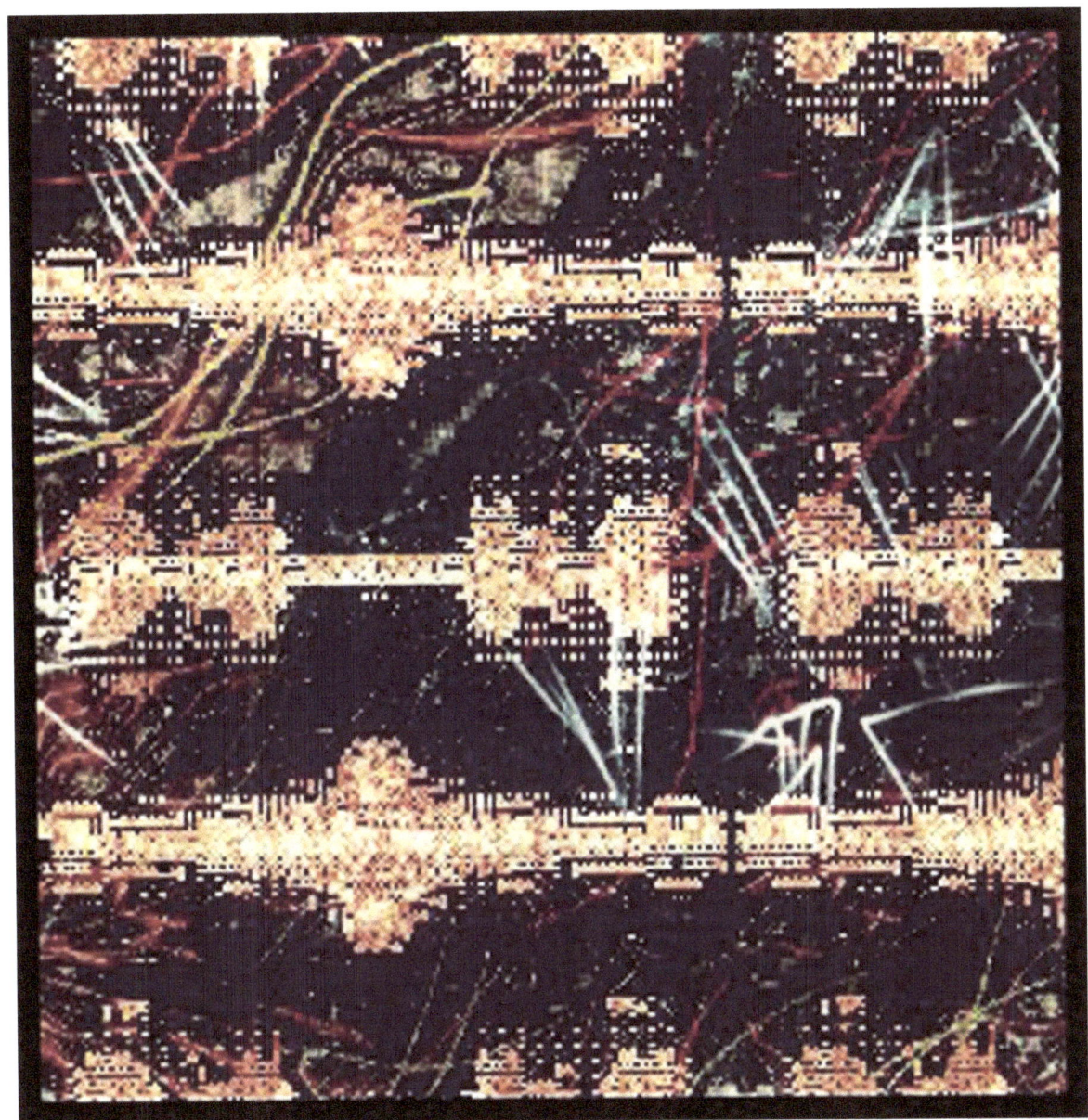

Sometimes the truth is a feeling and not something that is said.

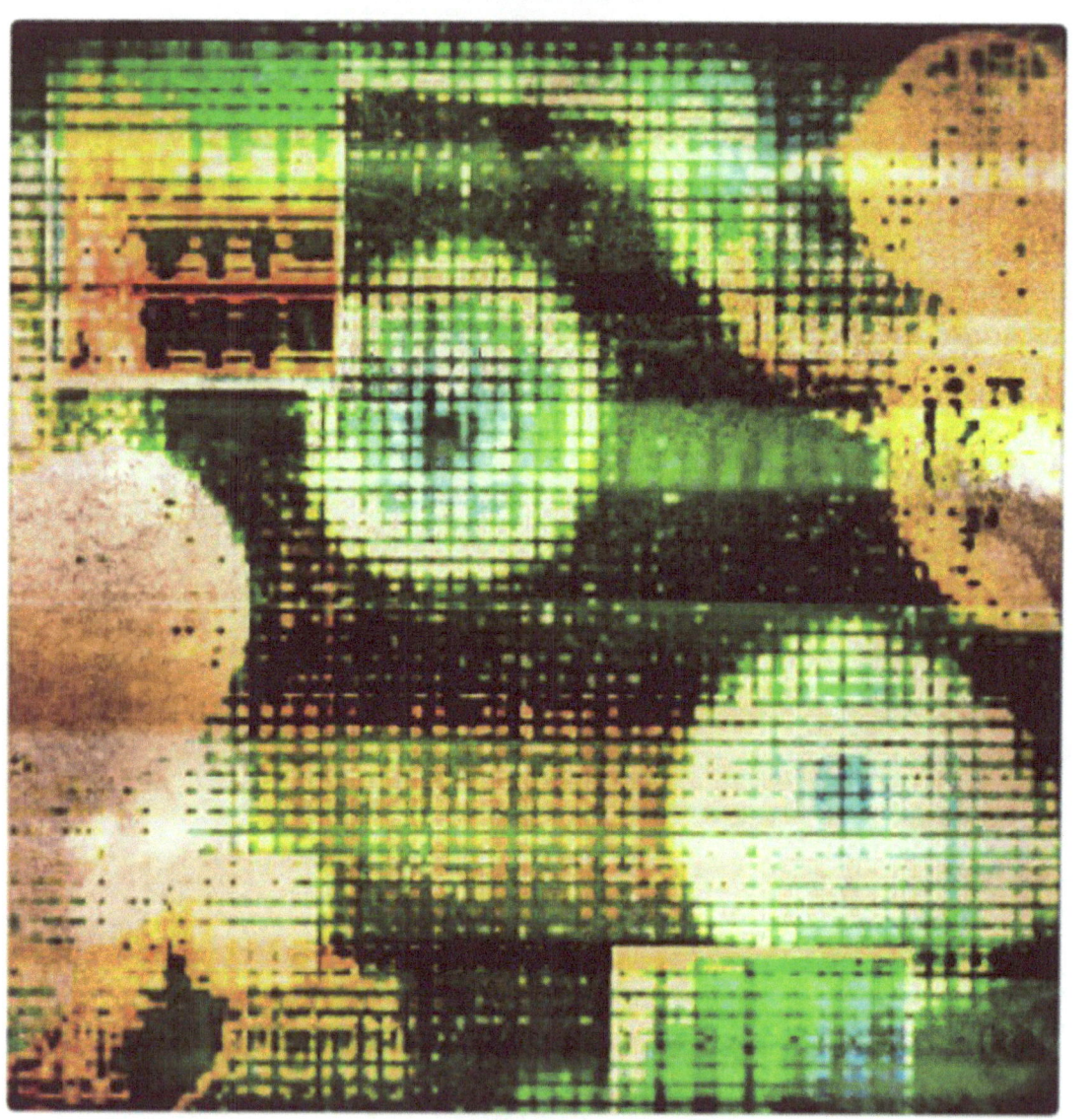

The reality of the situation was unreal.

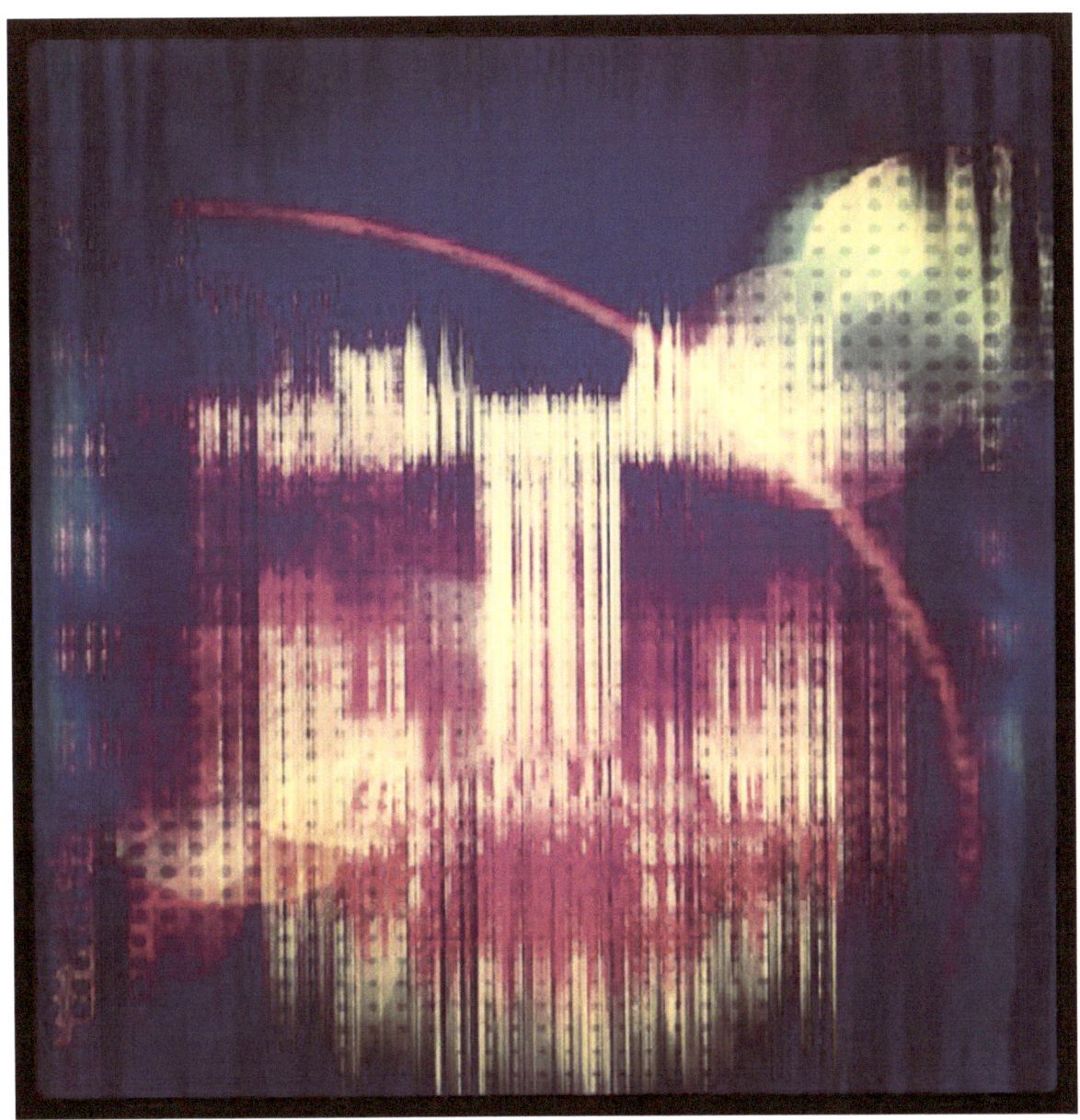

Everything was just like everyone thought. Even if there was no proof.

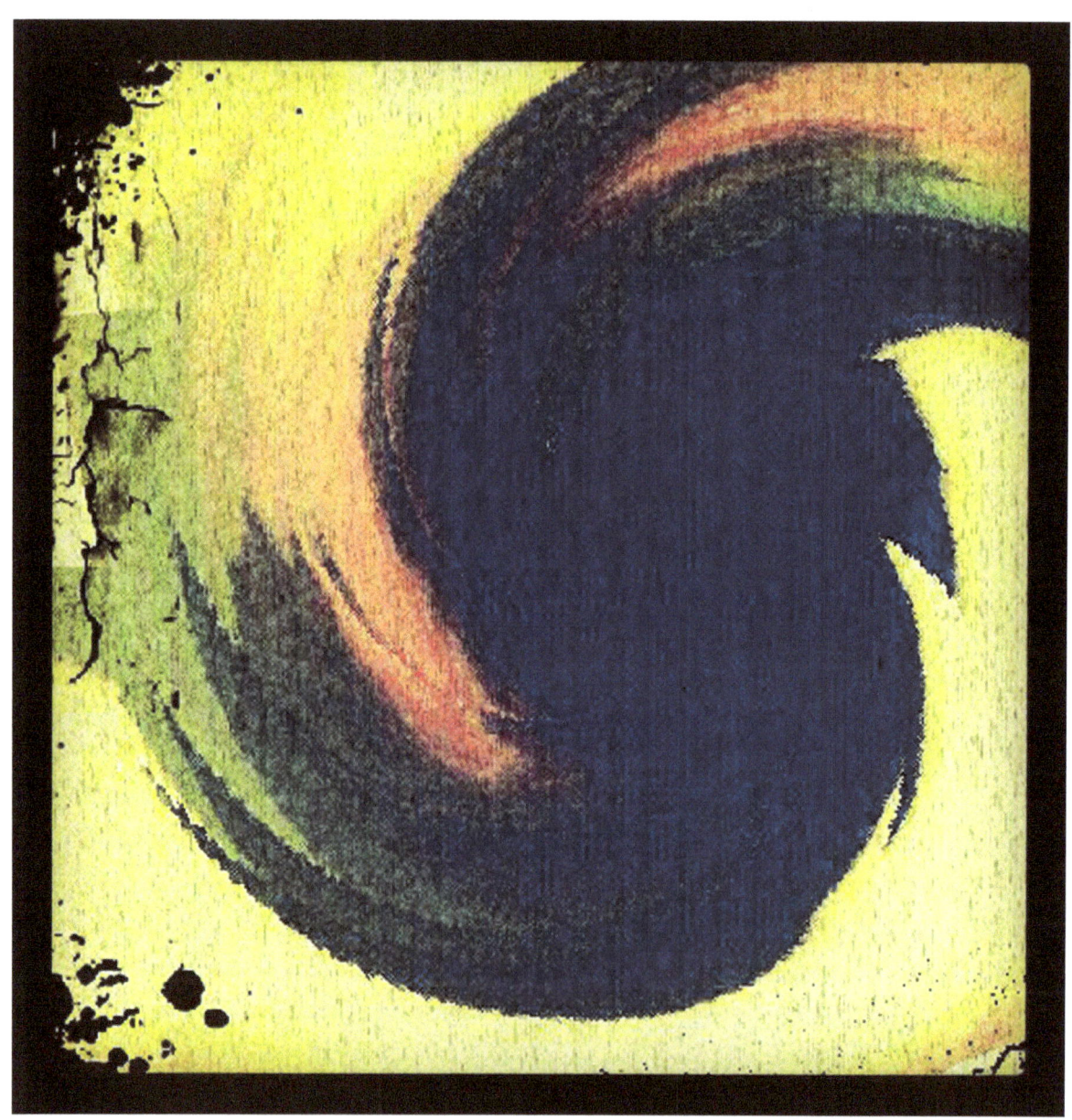

For all the pain he caused he was very good at what he did.

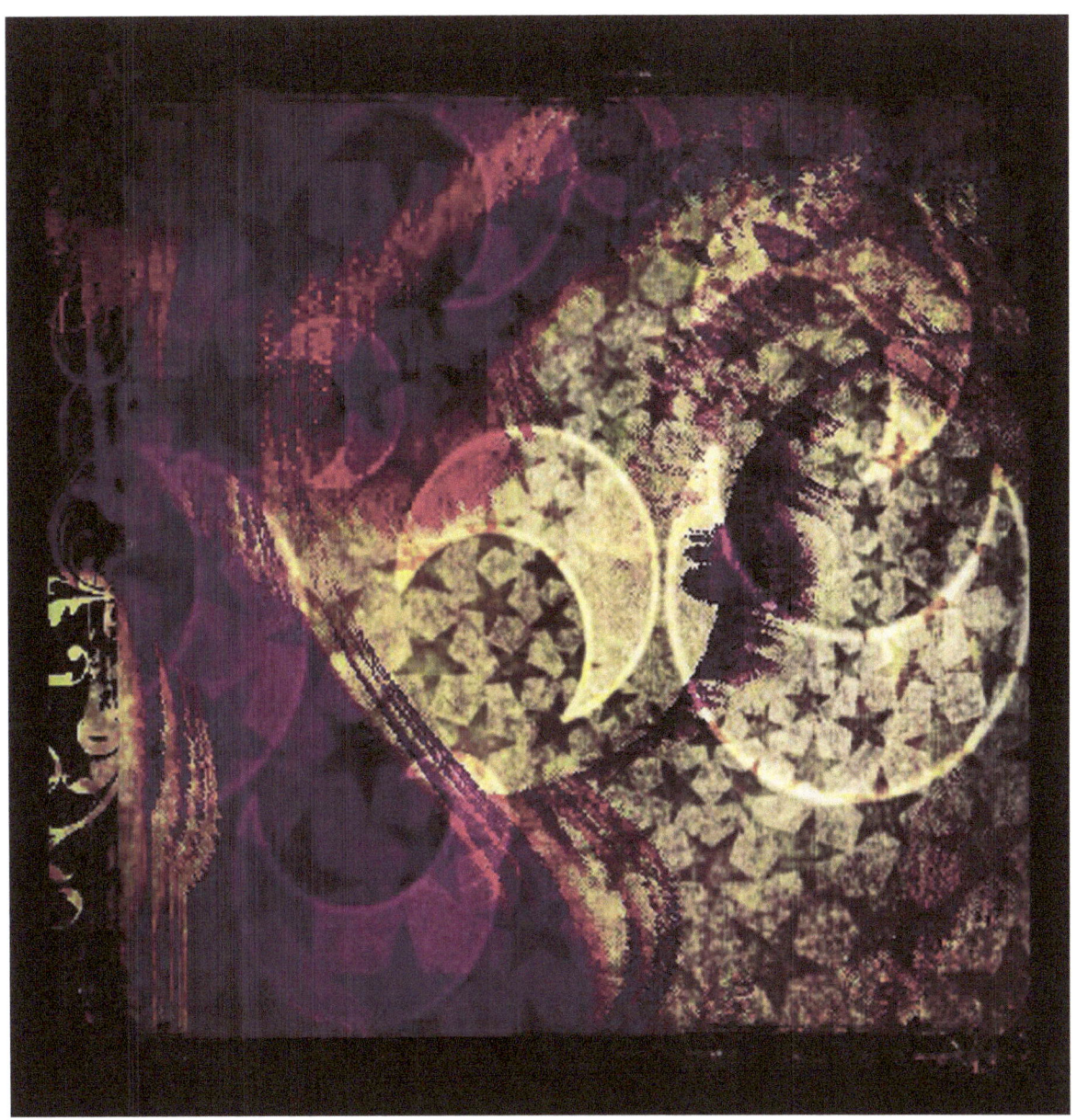

Because of her he found out the hard way there are worse things than dying.

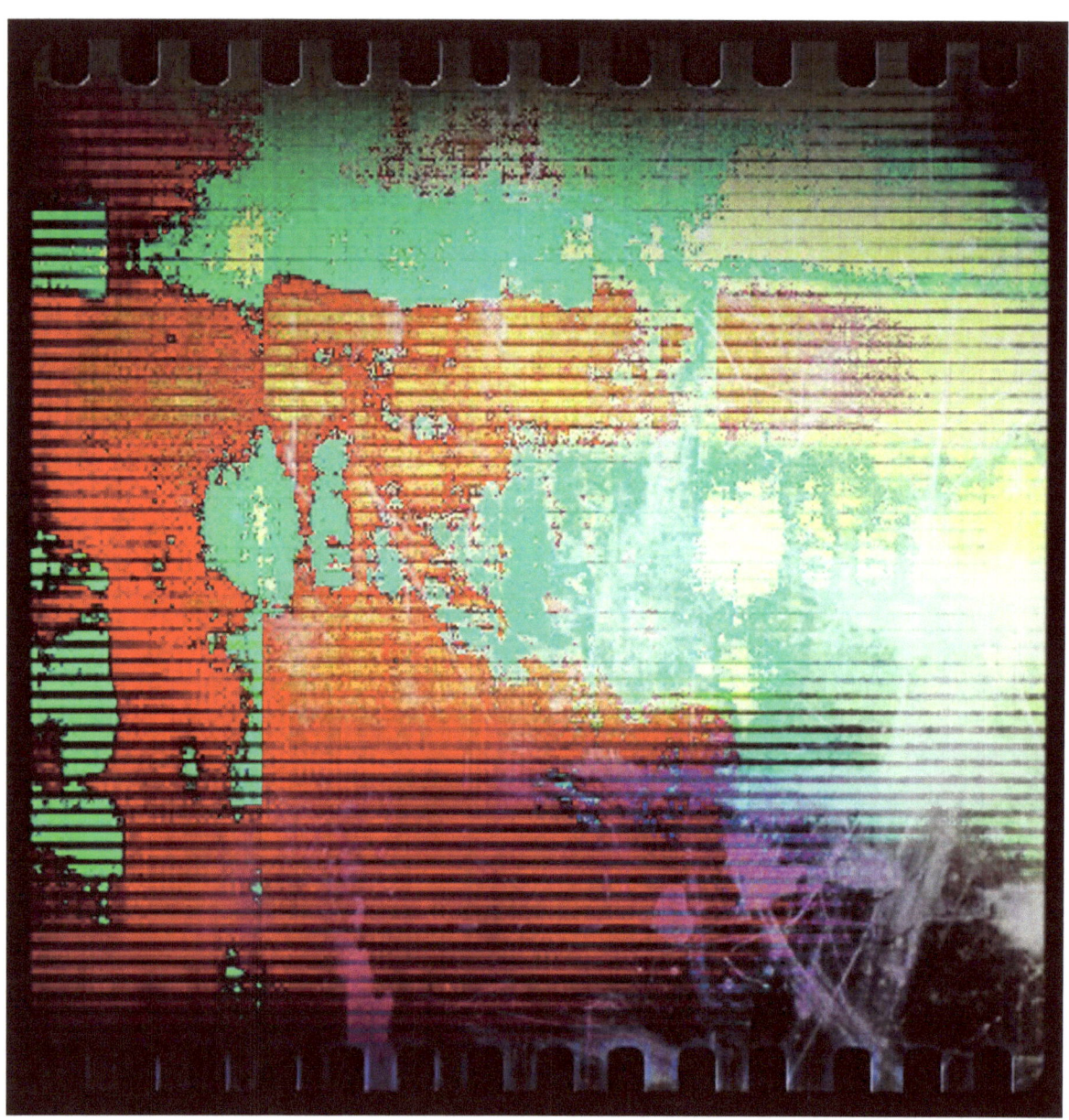

A better plan and a little privacy would have helped a lot.

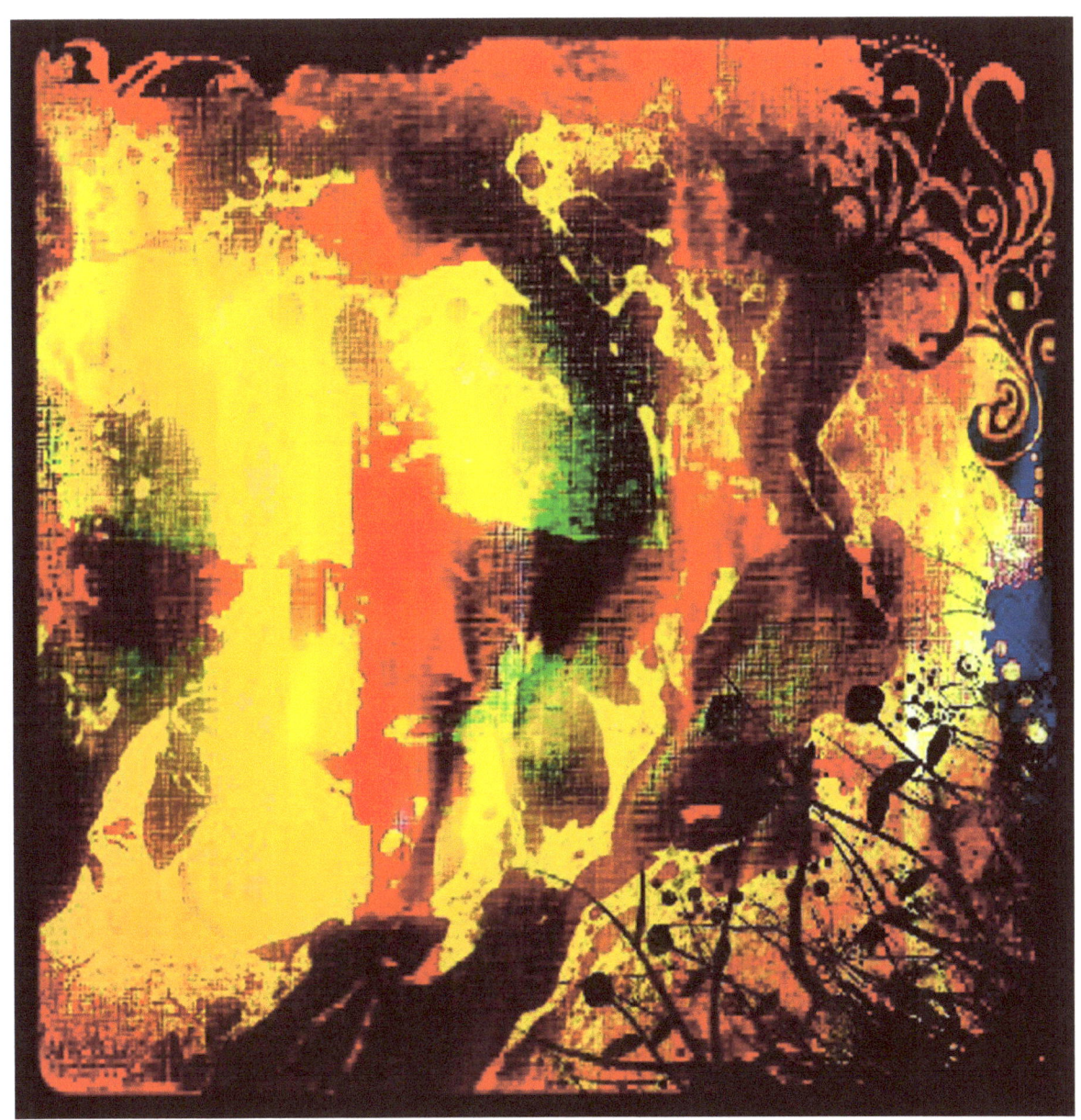

She was scared and had to be pushed over that ledge.

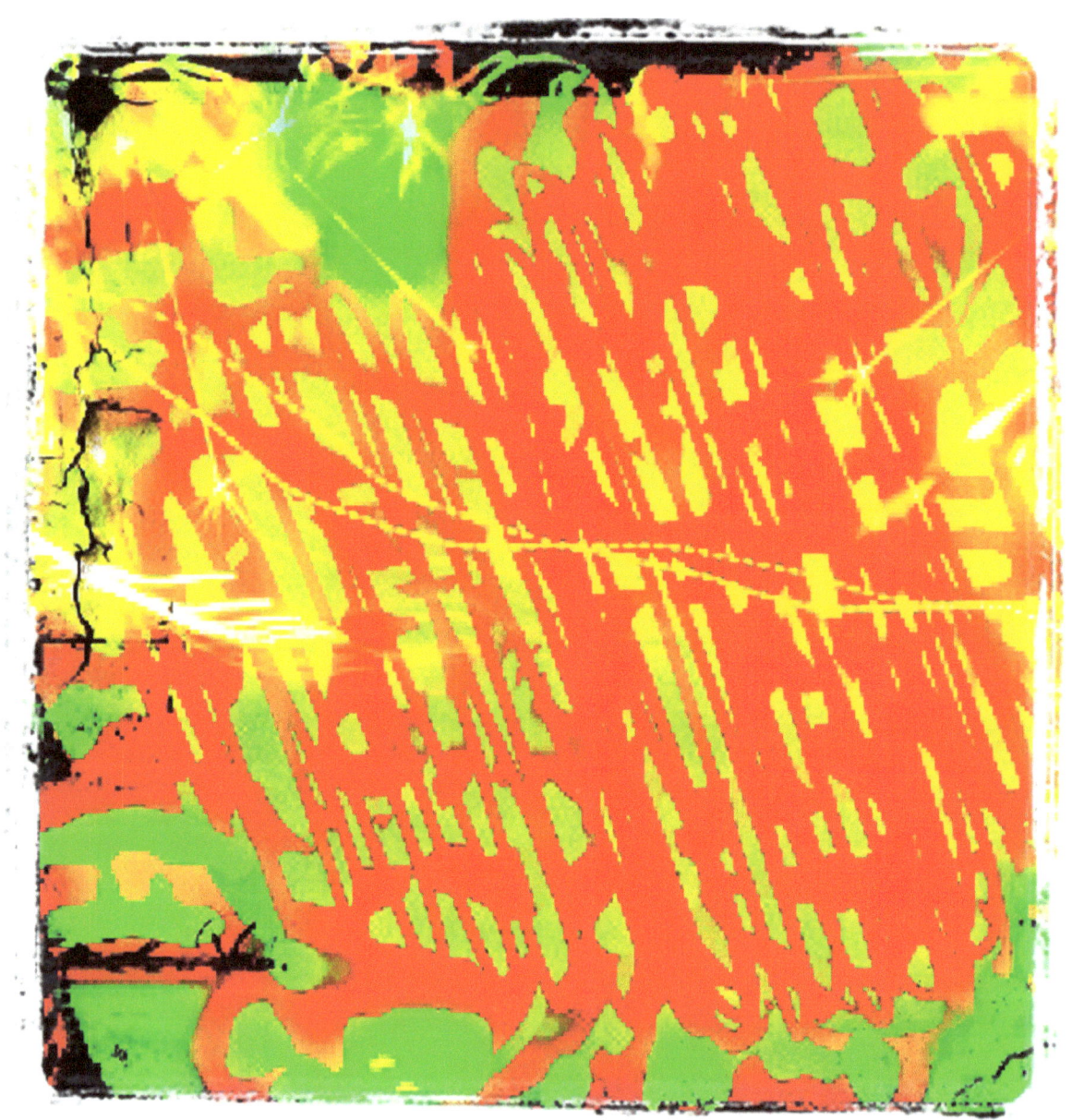

After all the pain you caused I wonder how you can even sleep at night.

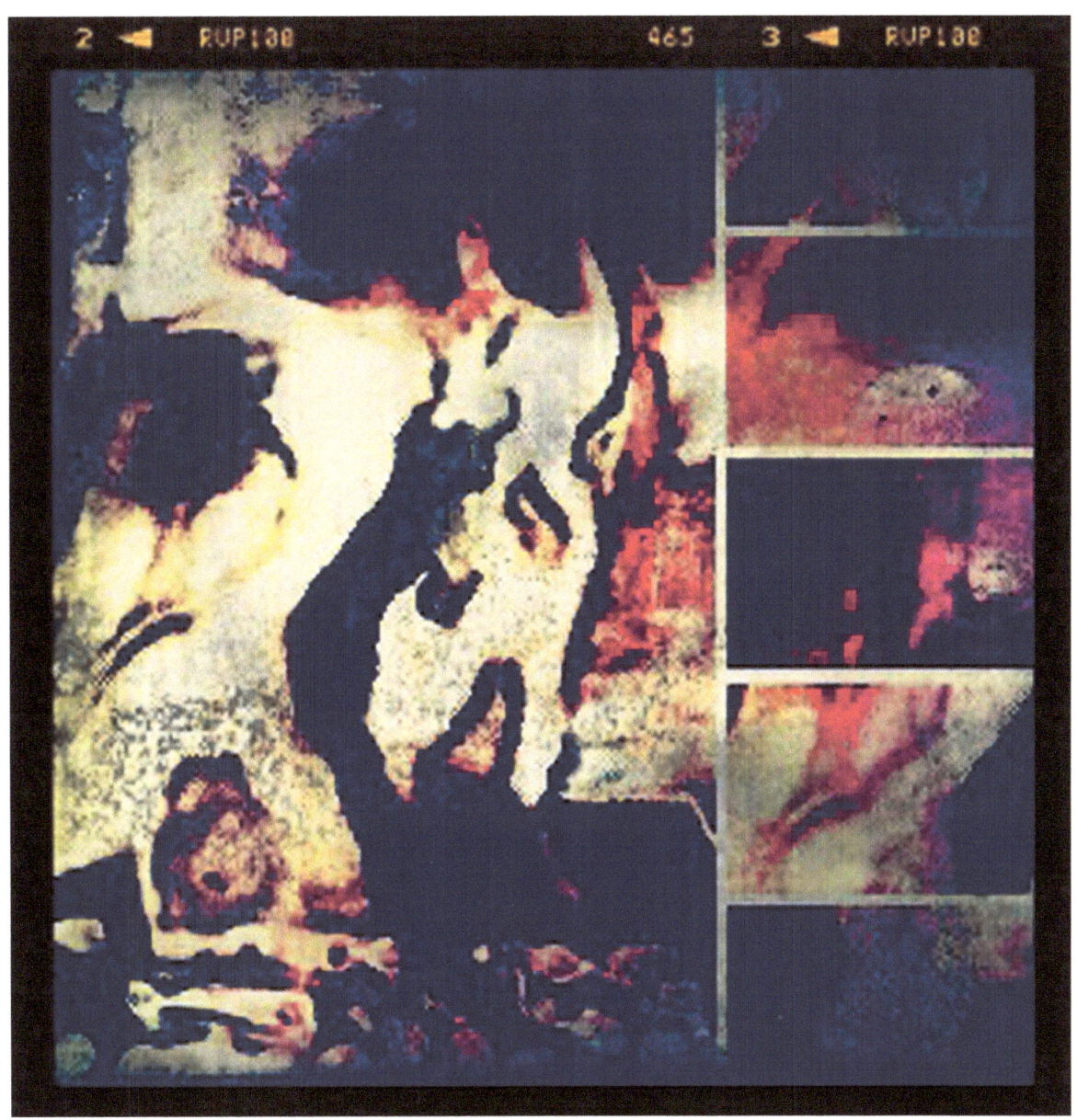

There was more to the story. There always is.

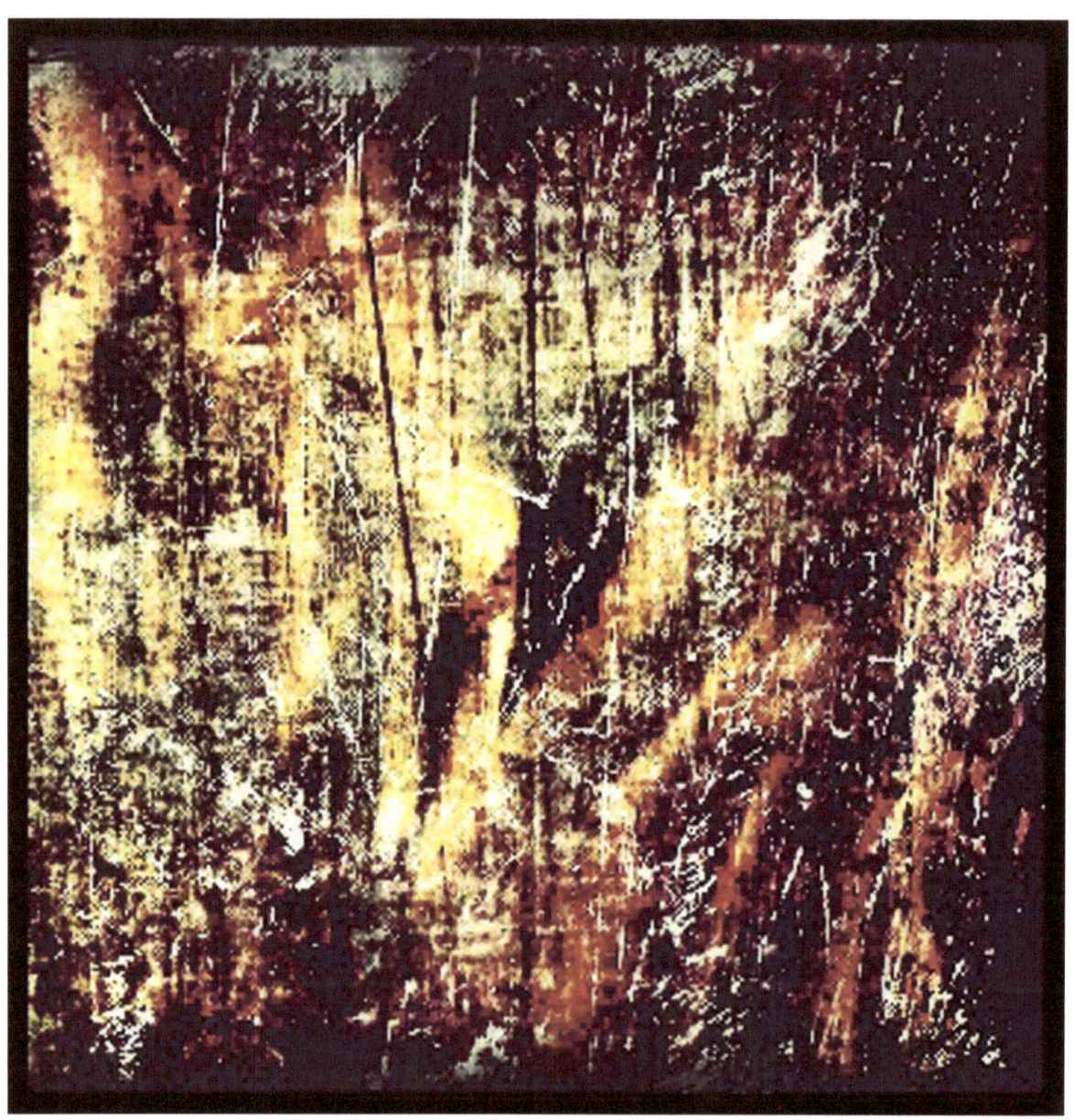

It was a matter of wanting it all. And then some.

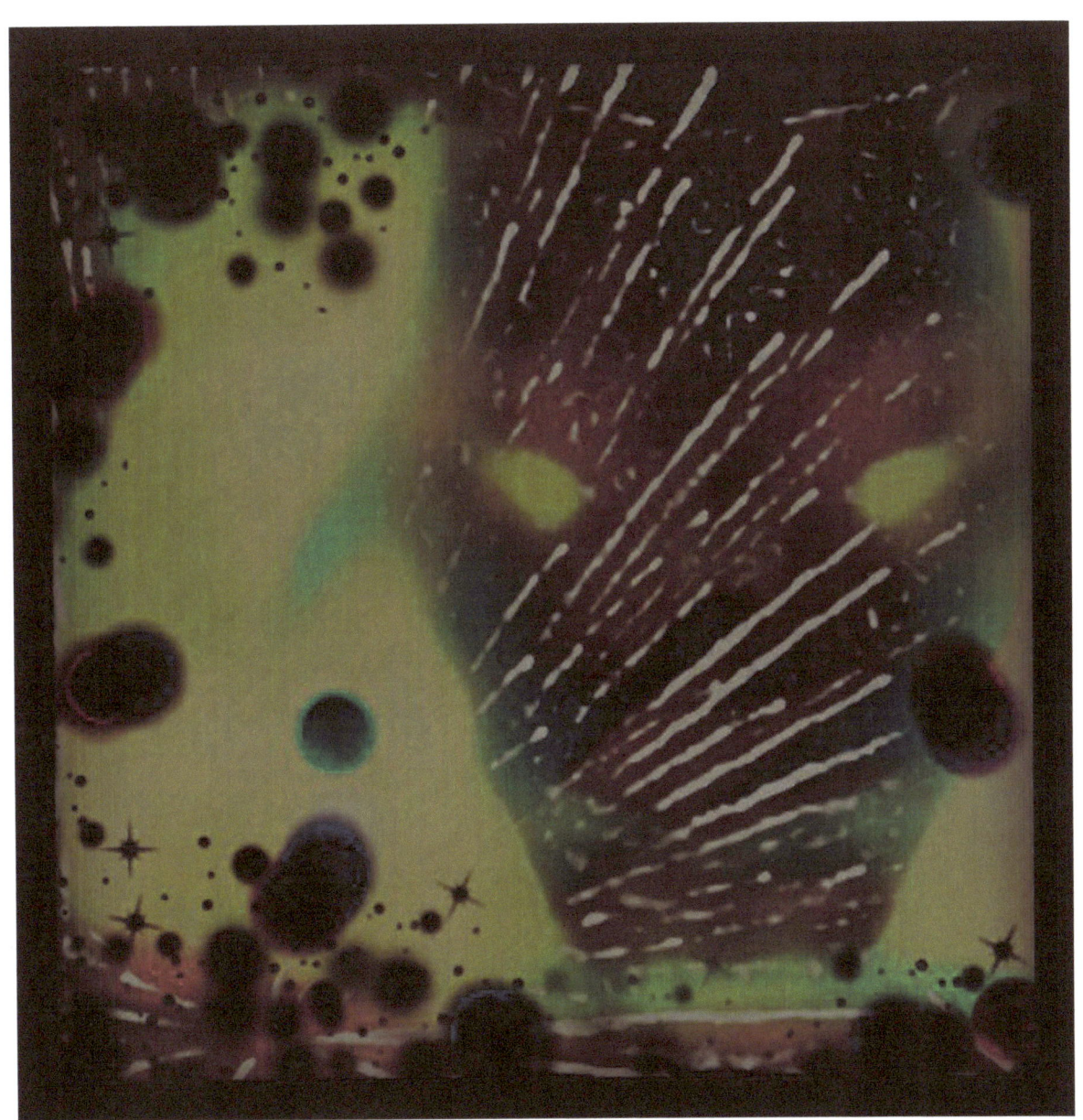

Danger can lurk around any corner.

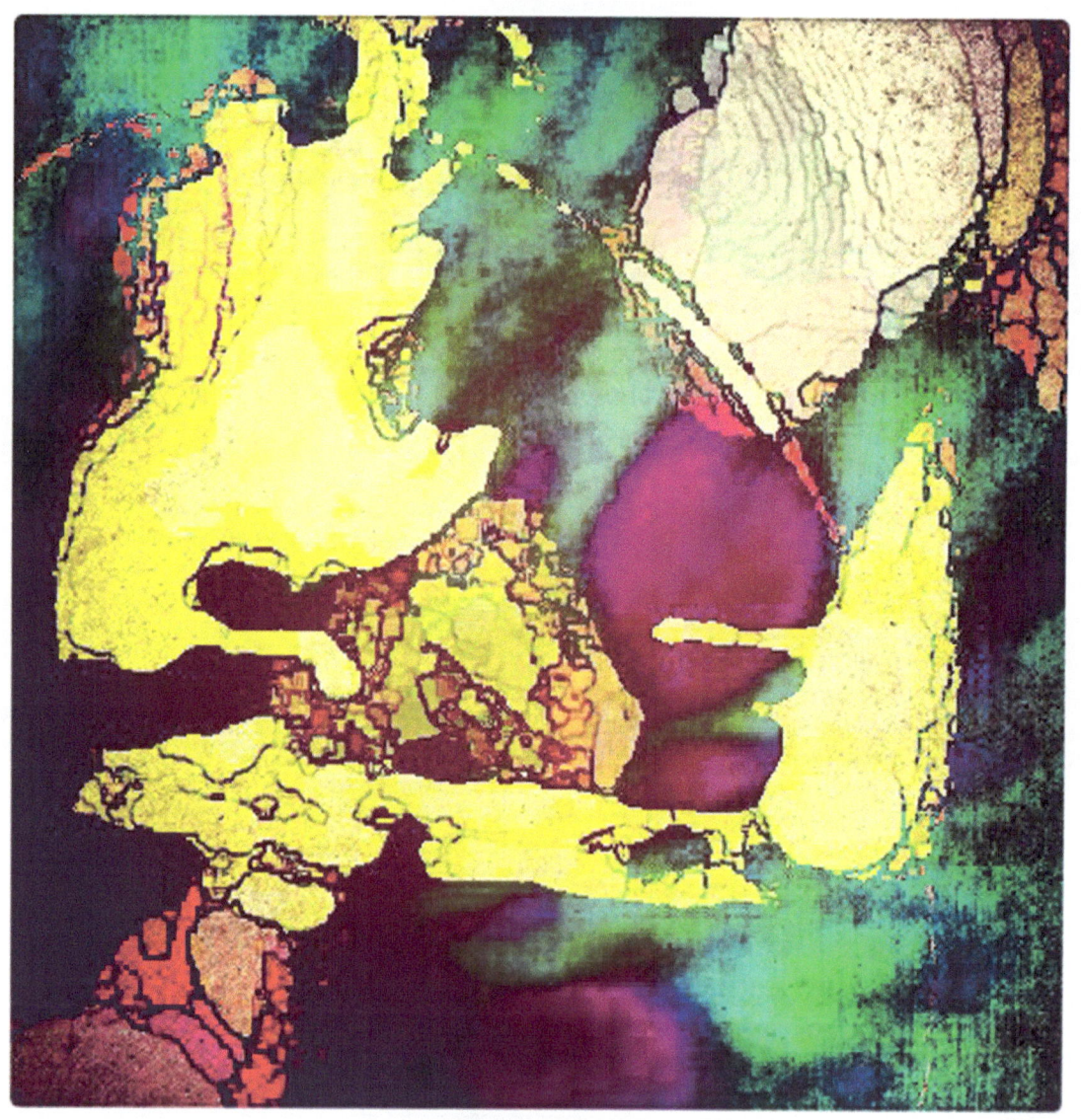

She tried everything she could but she just couldn't stay where she was any longer.

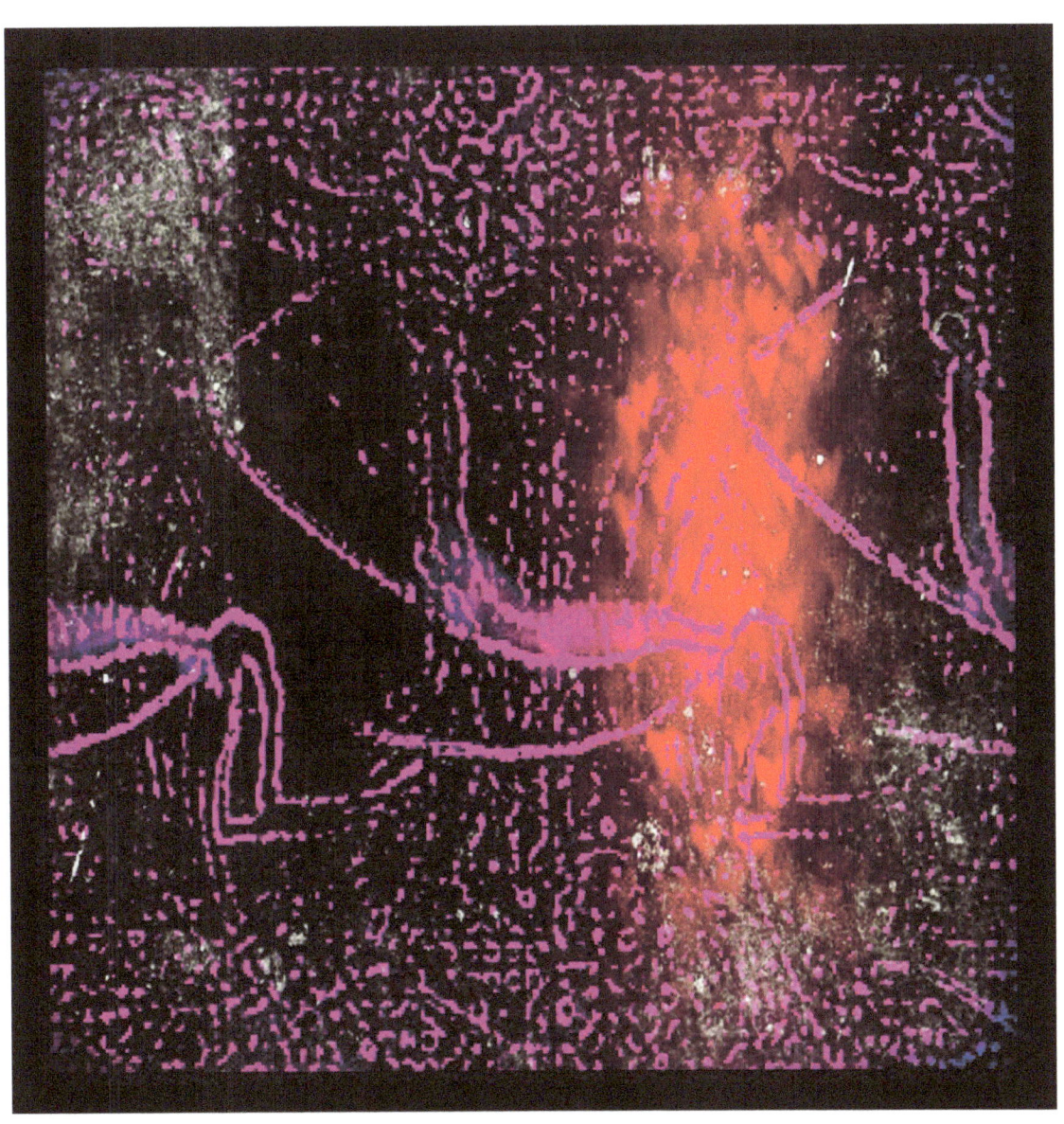

He didn't care who got hurt as long as he got what he needed. Whatever it took to keep her happy.

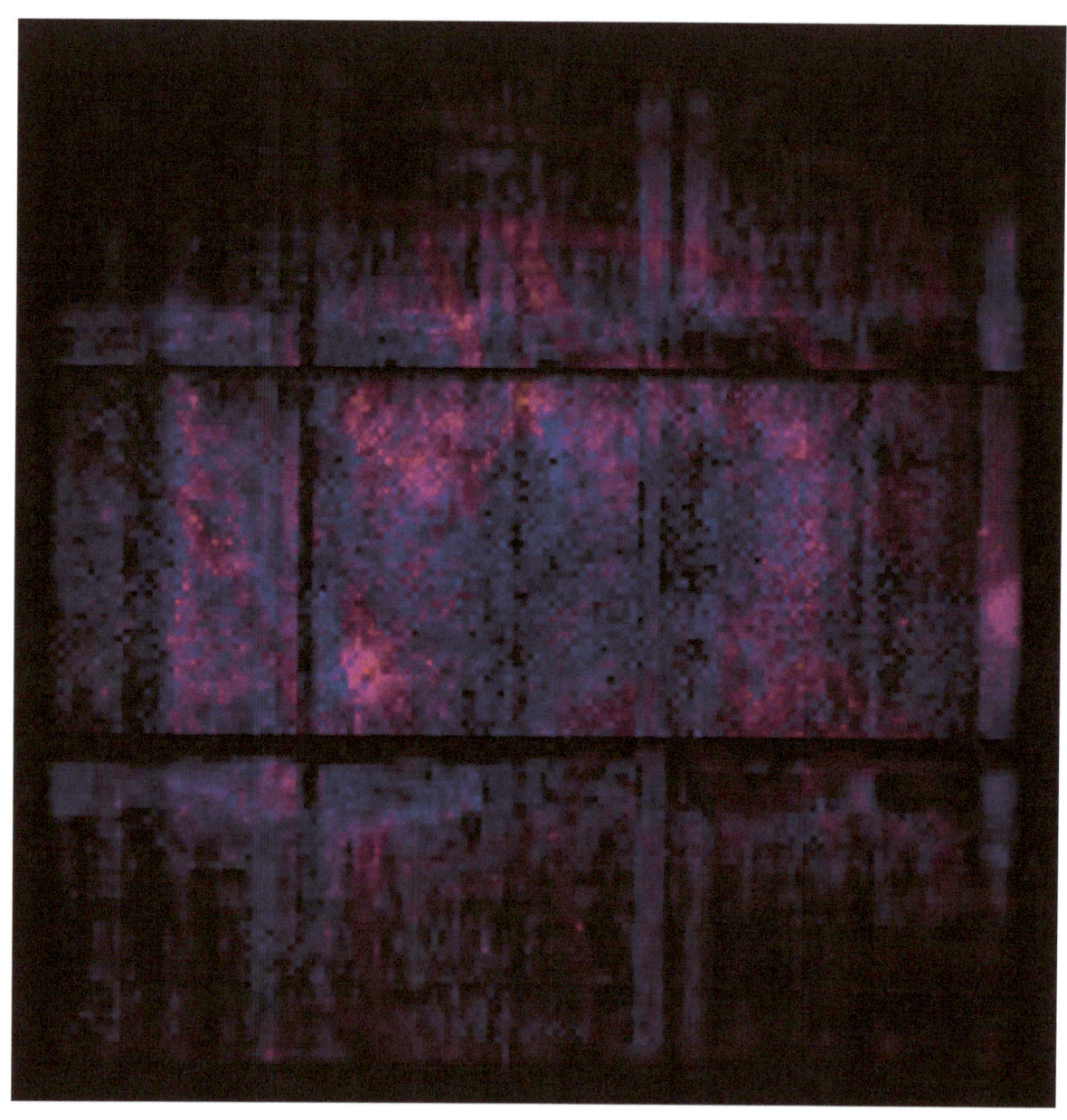

He knew exactly where he was going.

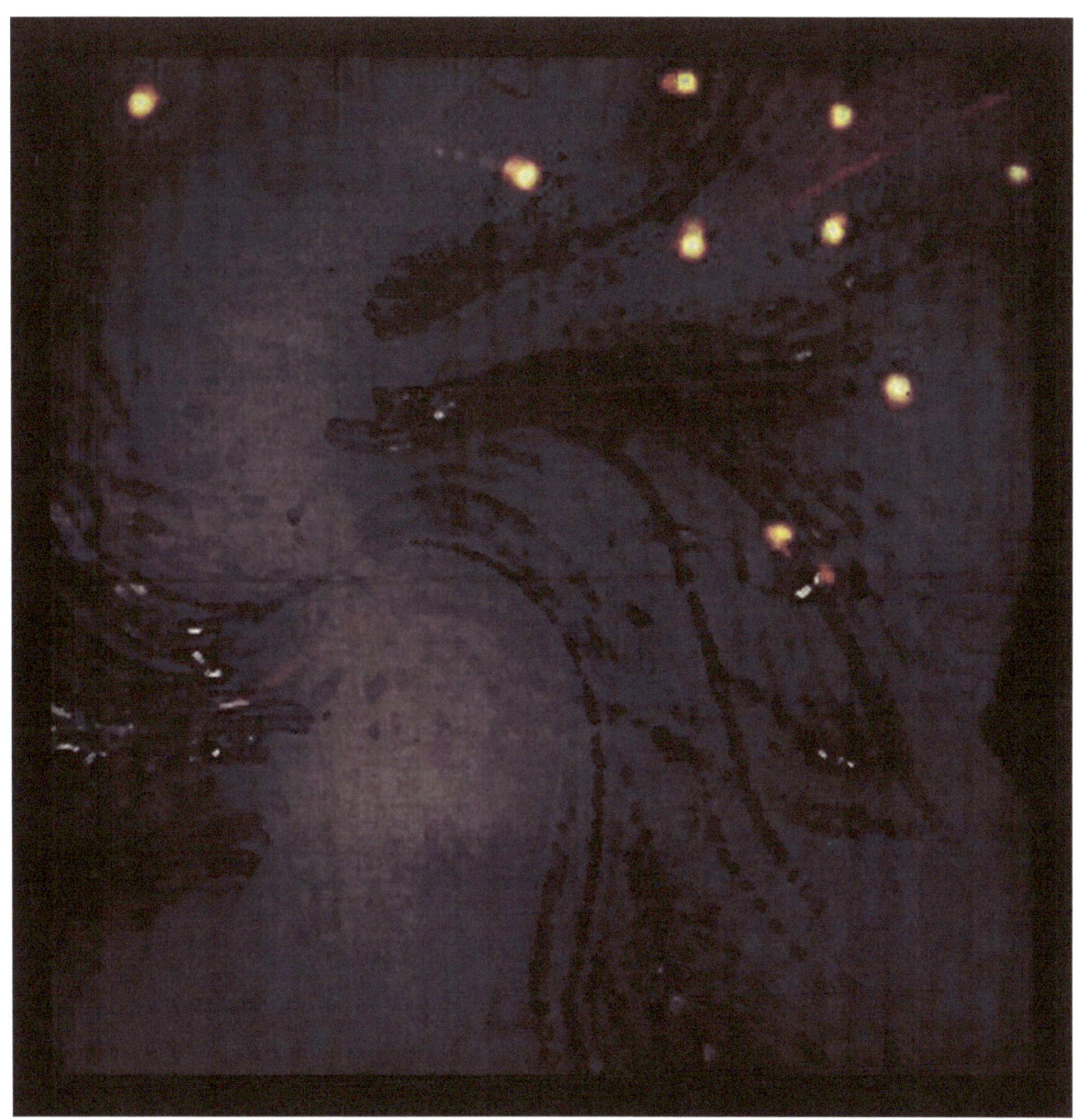

She was saved because she didn't follow the rules.

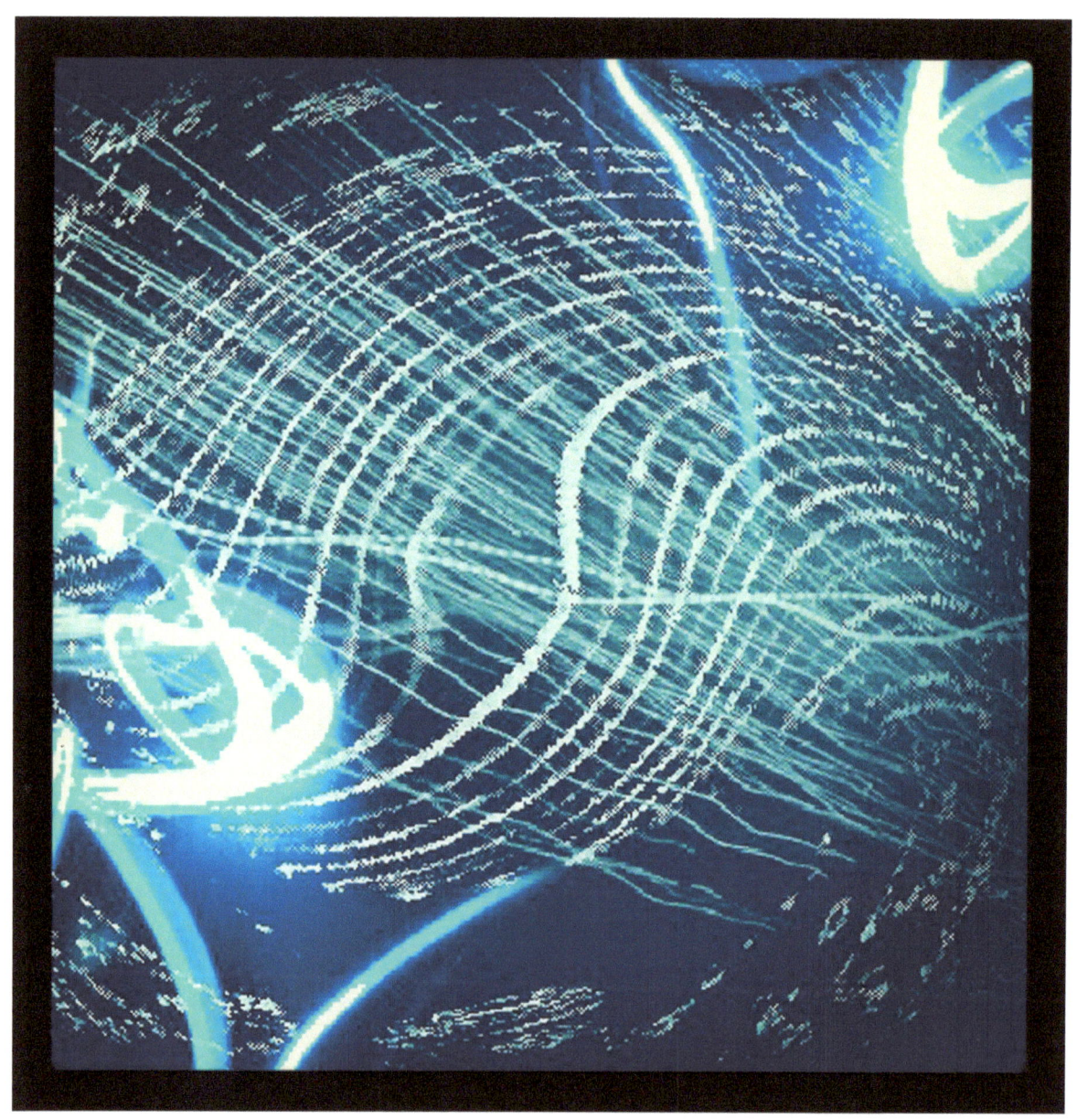

She knew exactly what she wanted and how to get it.

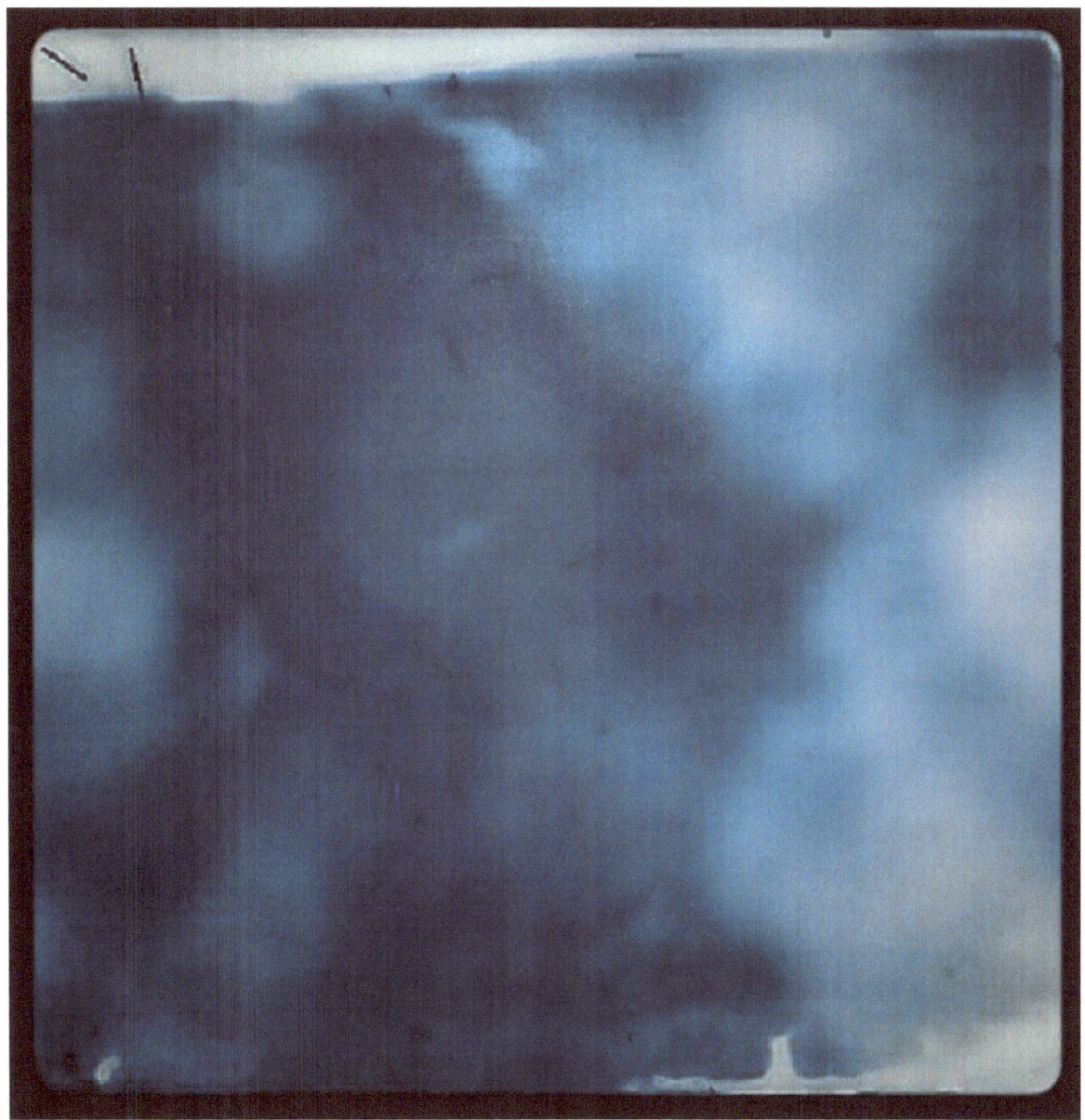

She was reluctant but still willing.

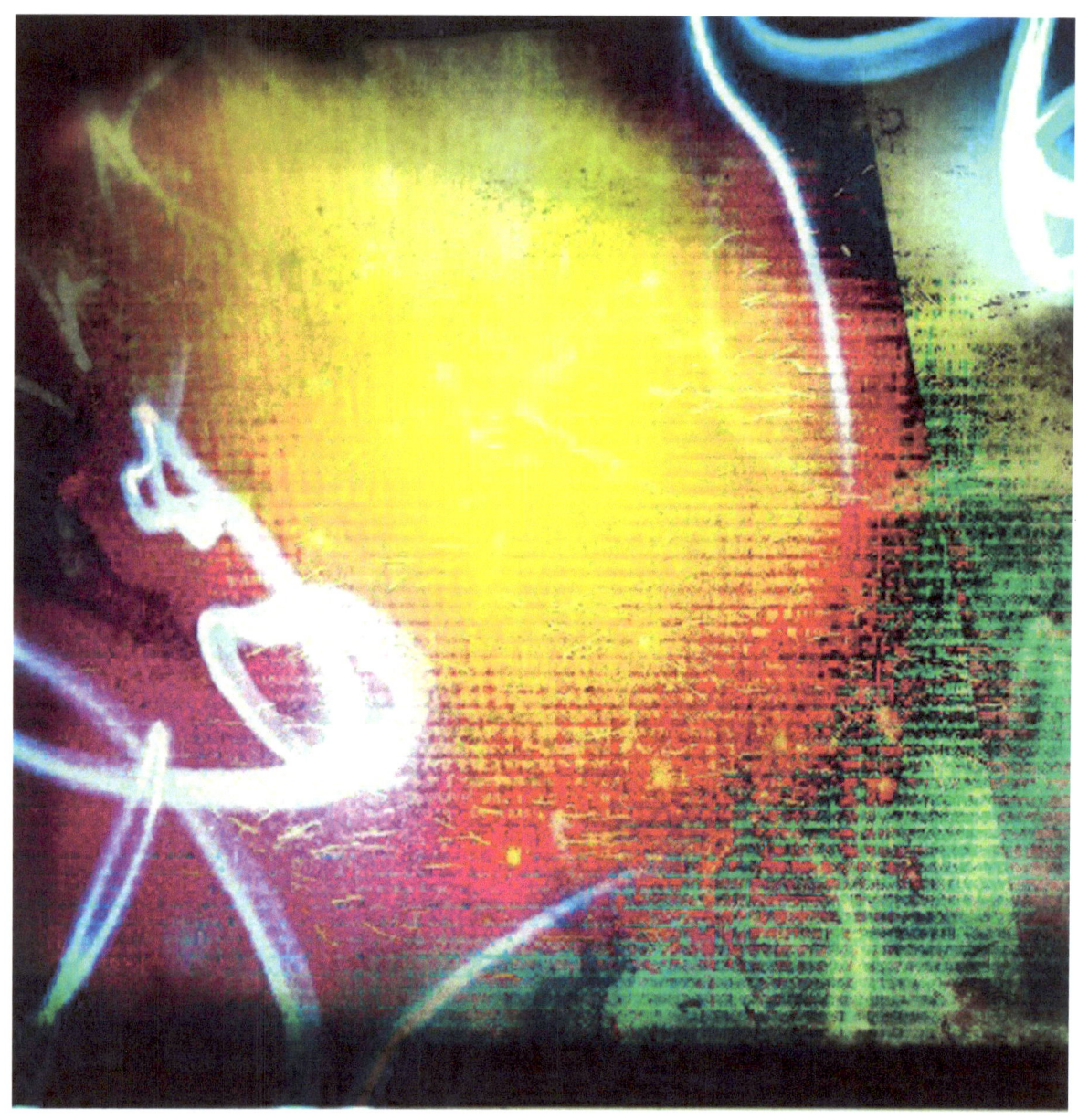

Some people see no reason to say goodbye when they leave.

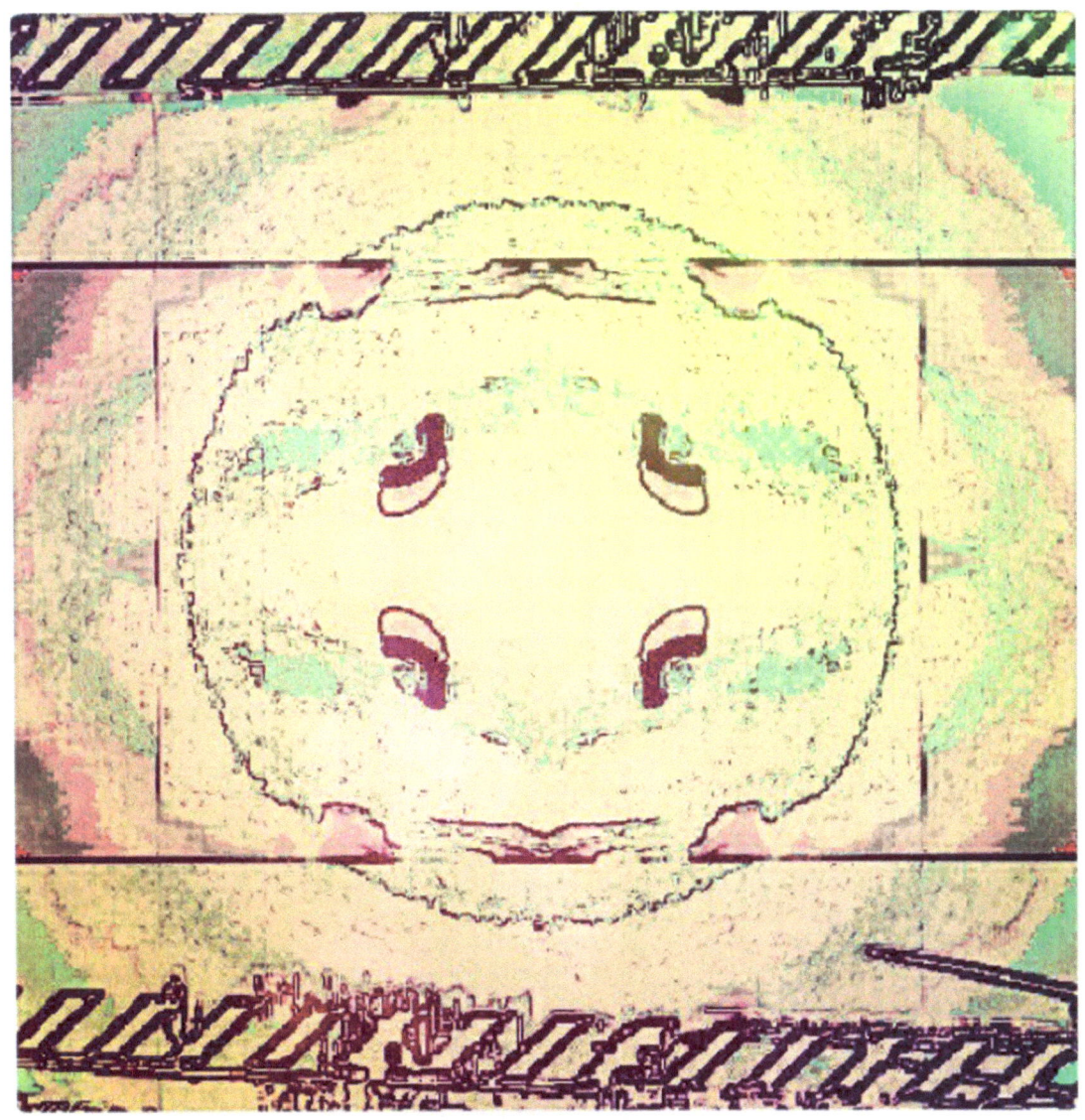

She was the lawless one but they both paid with their lives.

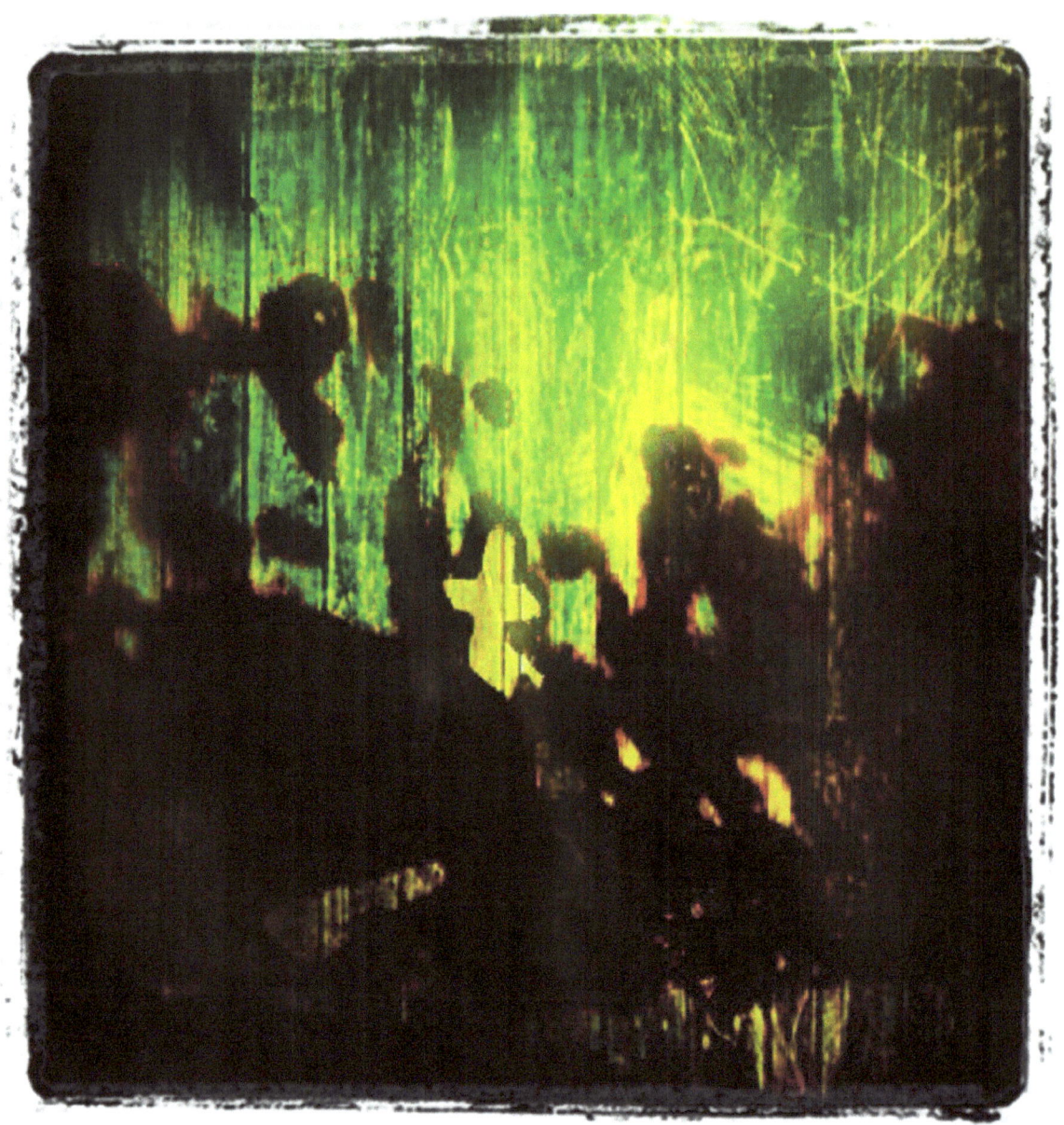

The thing I remember most is her big smile.

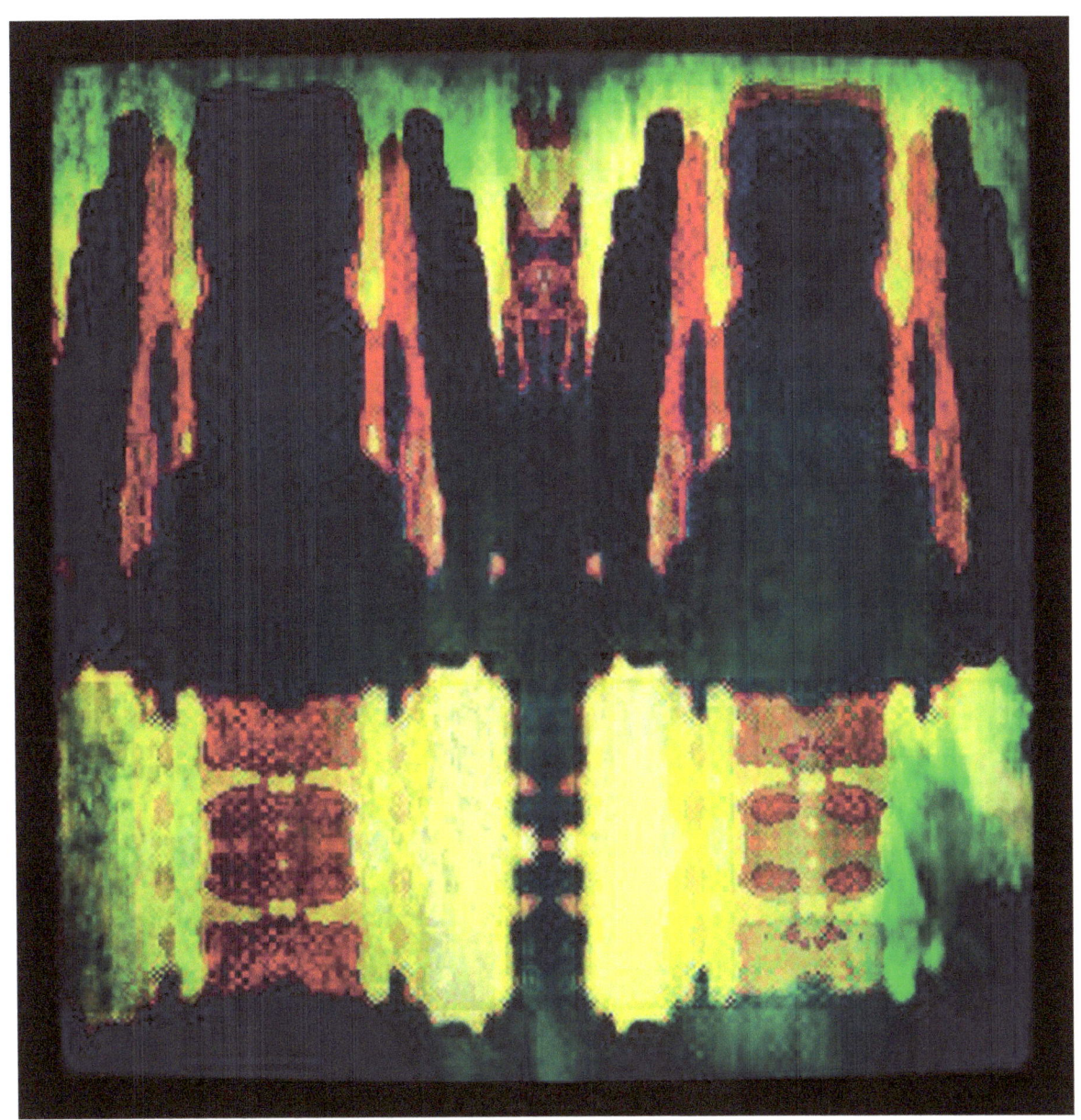

It was more a surprise how he died than that he was dead.

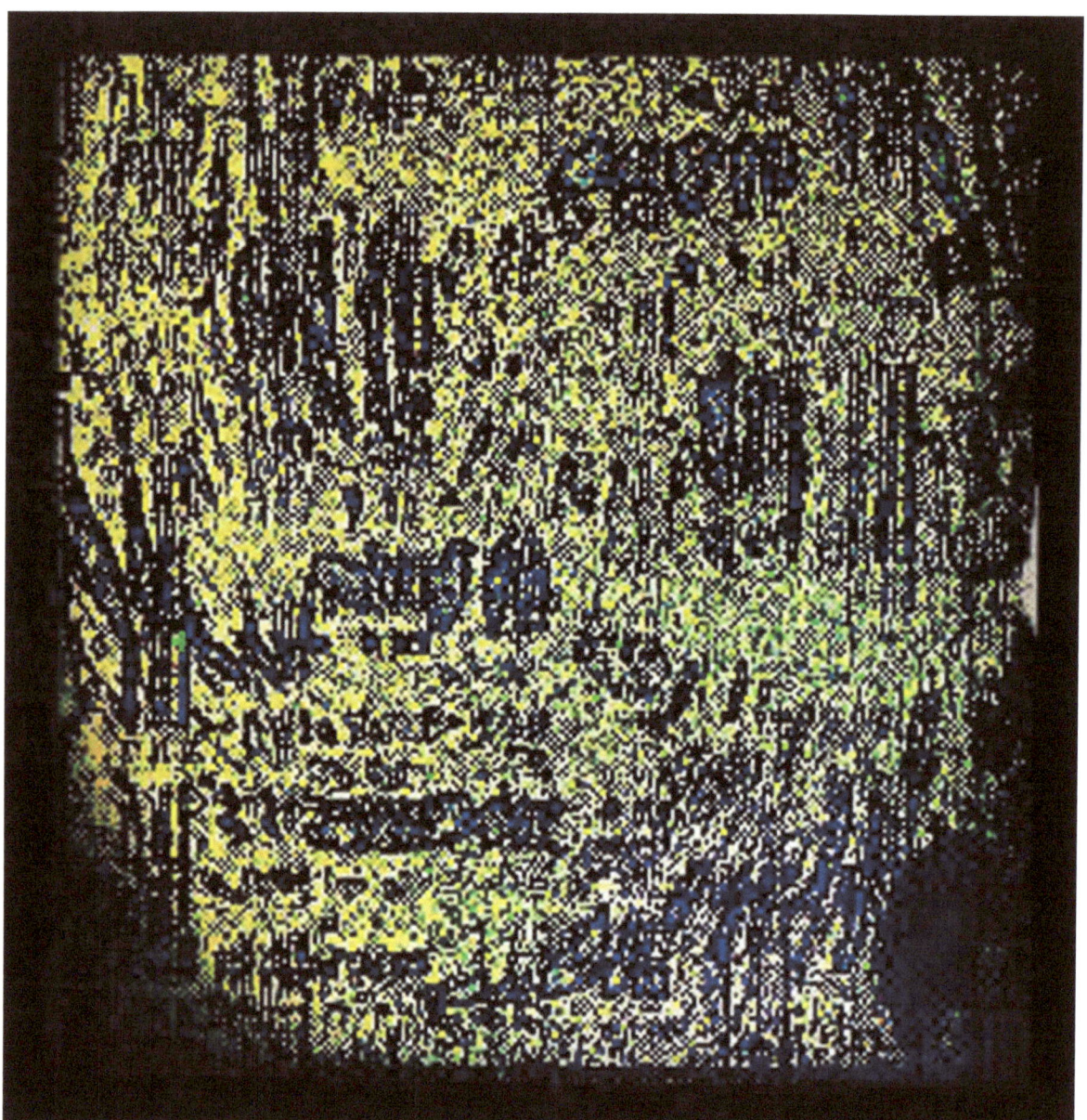

True love always ends in tragedy. Always.

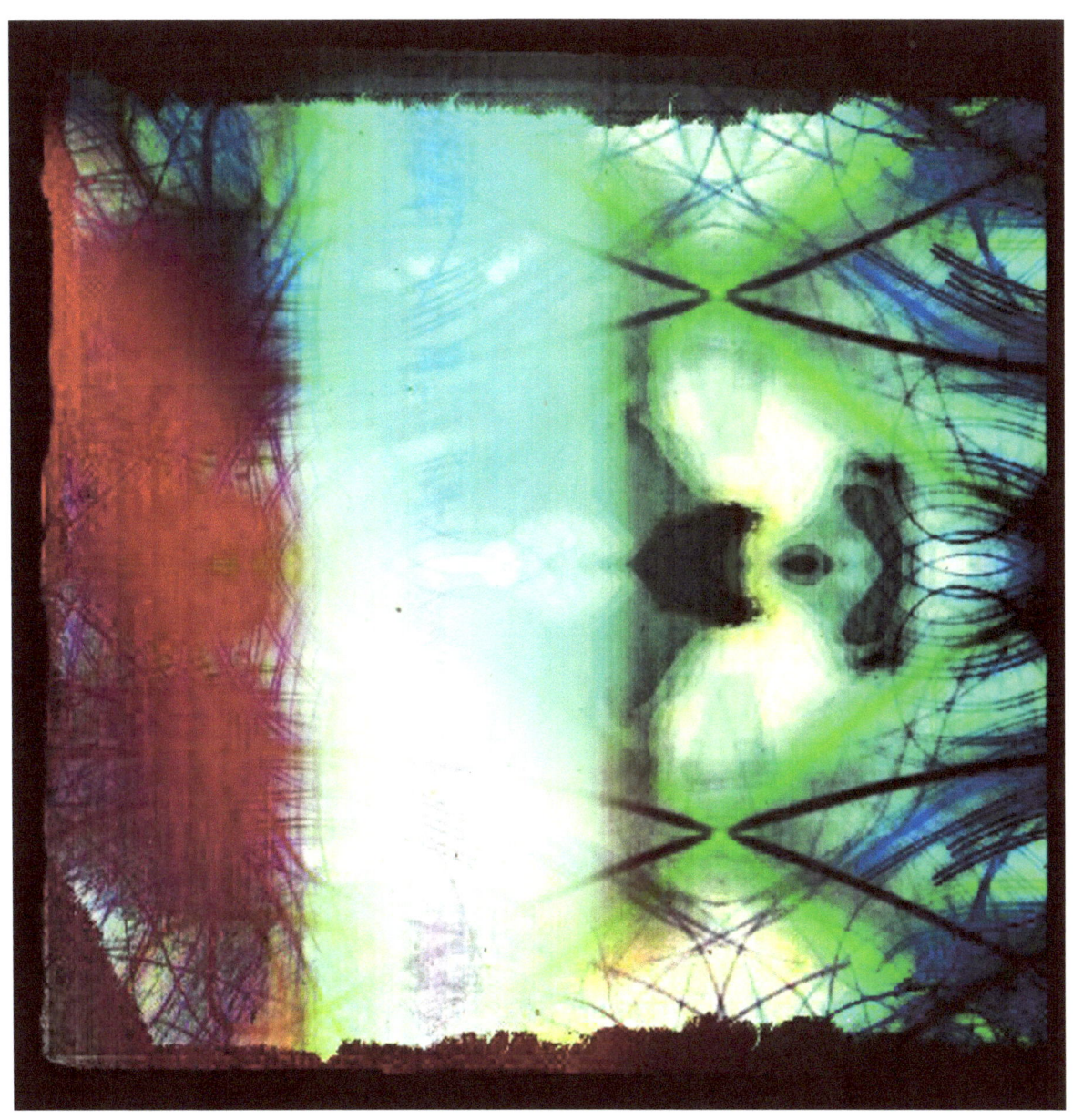

He was willing to do whatever was needed to set things right.

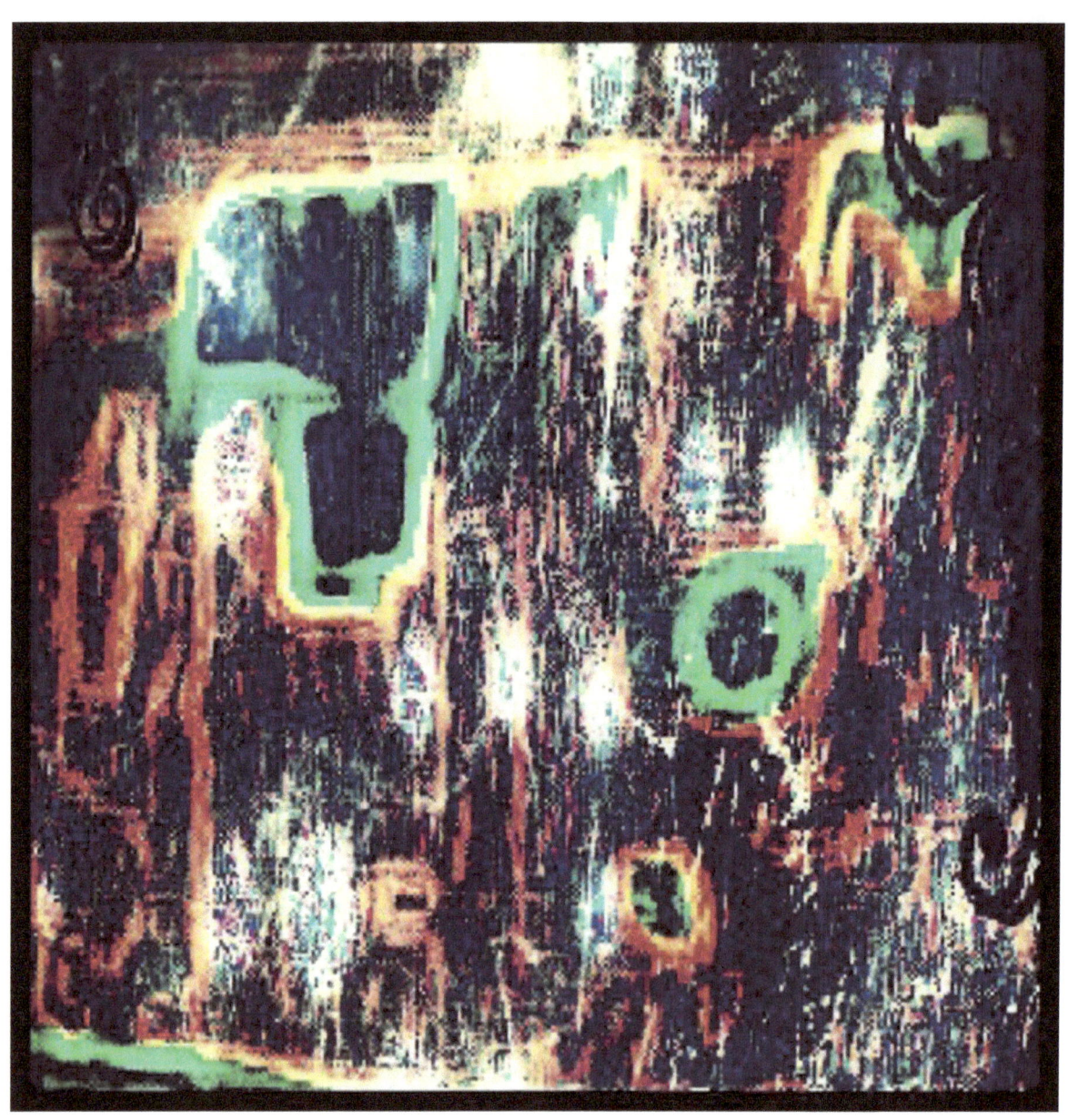

It was to serve as a reminder in tainted blood.

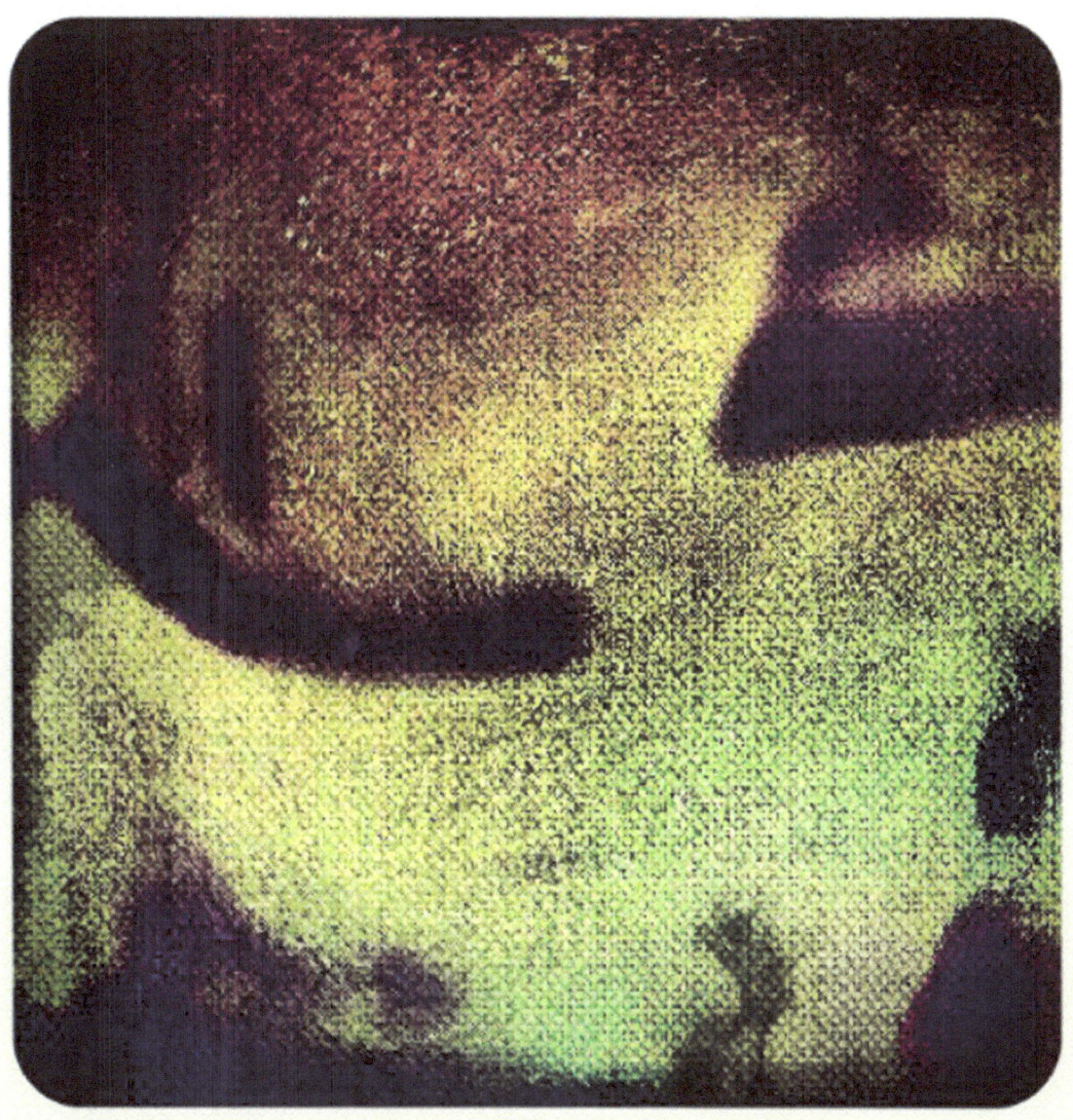

It was love that brought their relationship to its final end.

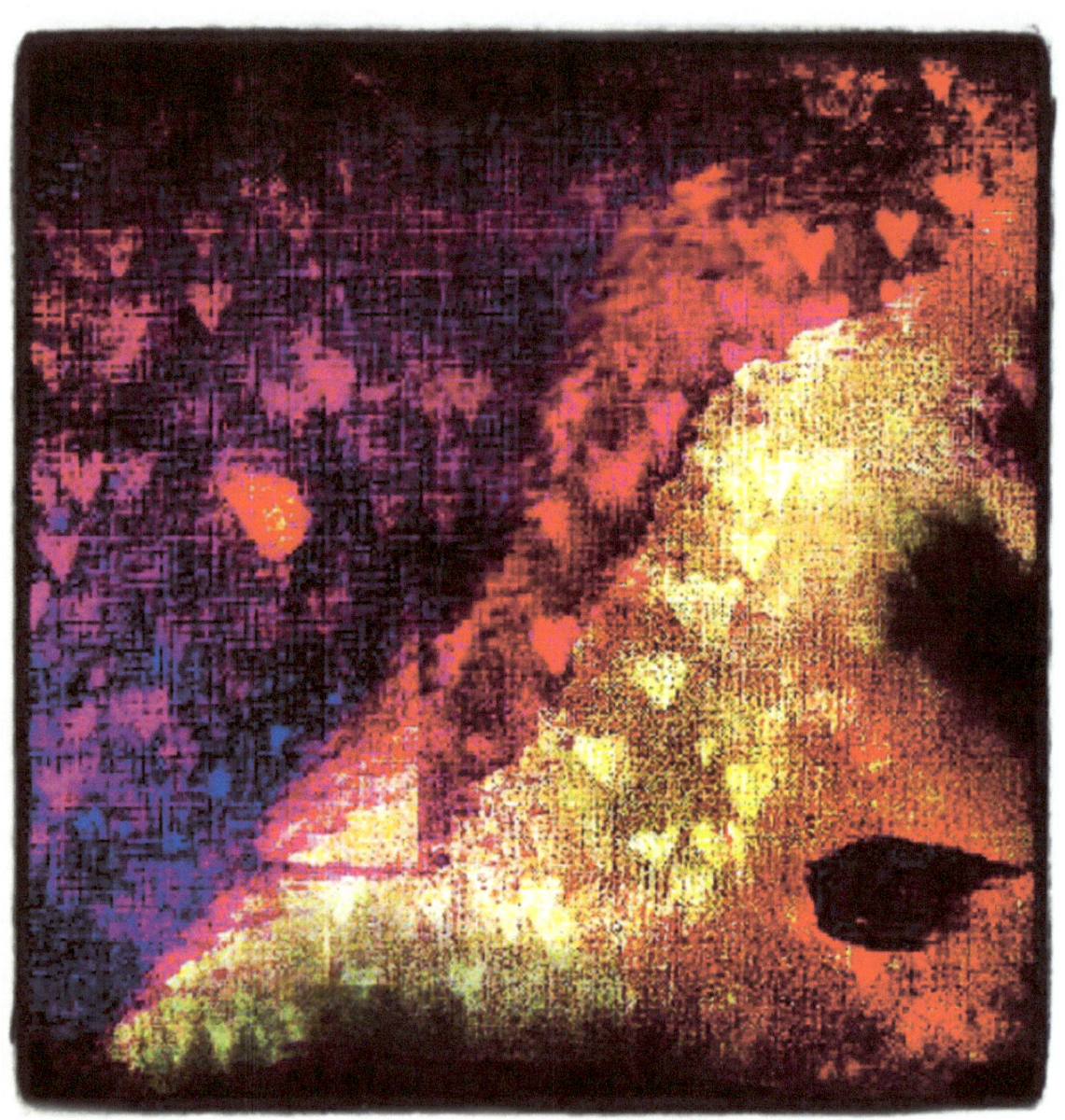

The drug usage was not the reason she became a person you didn't know.

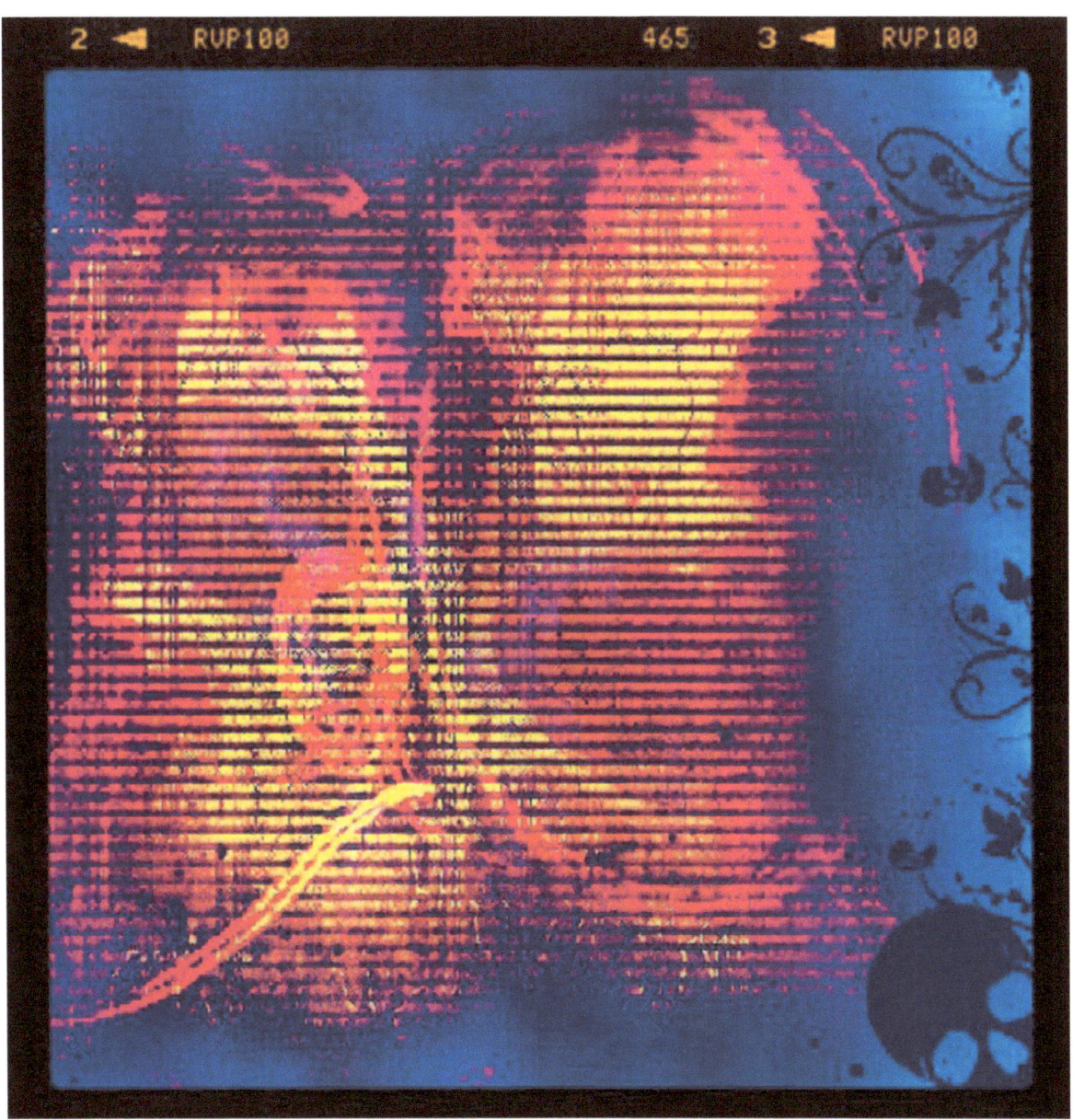

They don't think he is as guilty as may have previously been claimed.

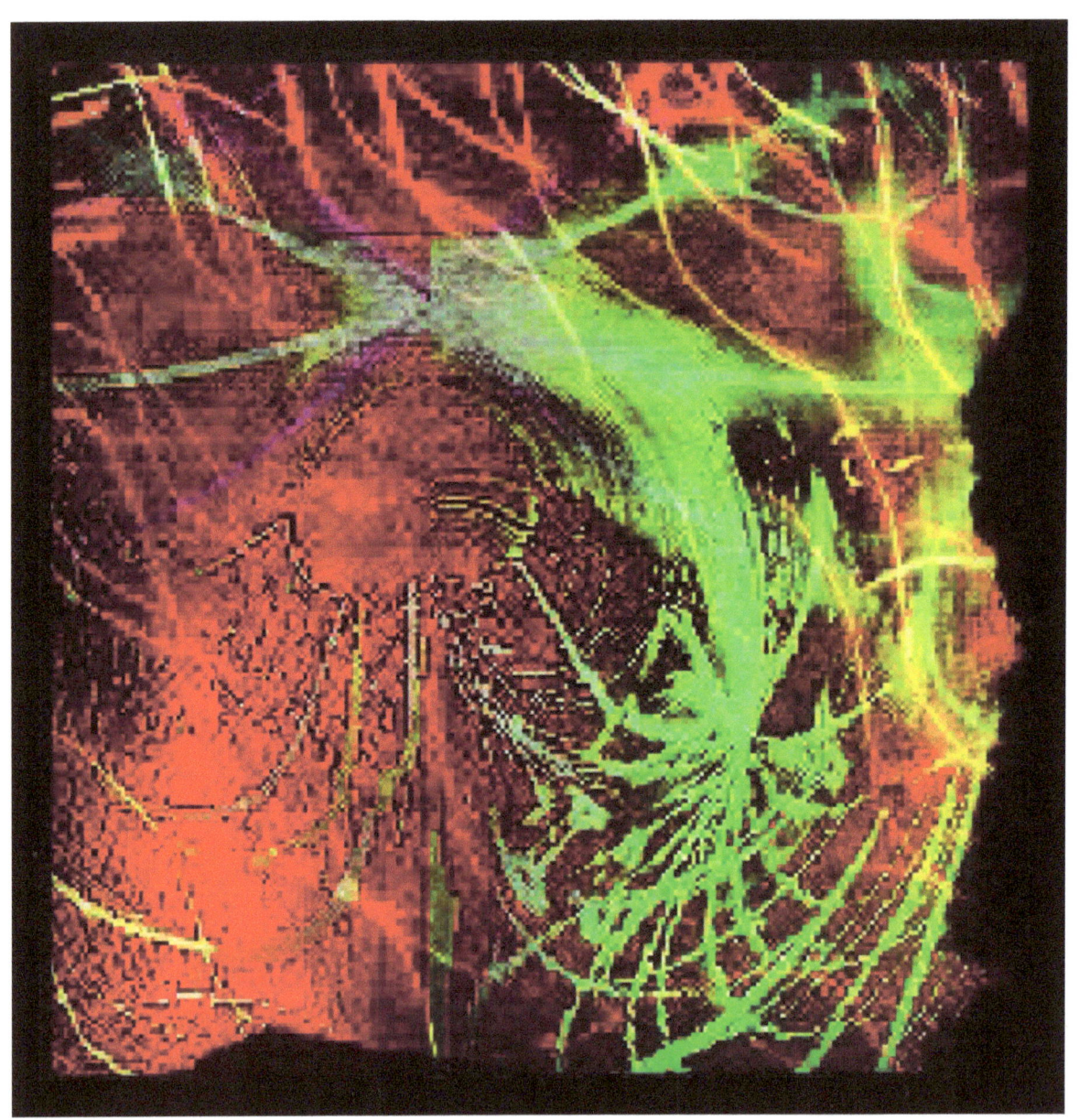

Did he feel he was being trapped in a loveless relationship?

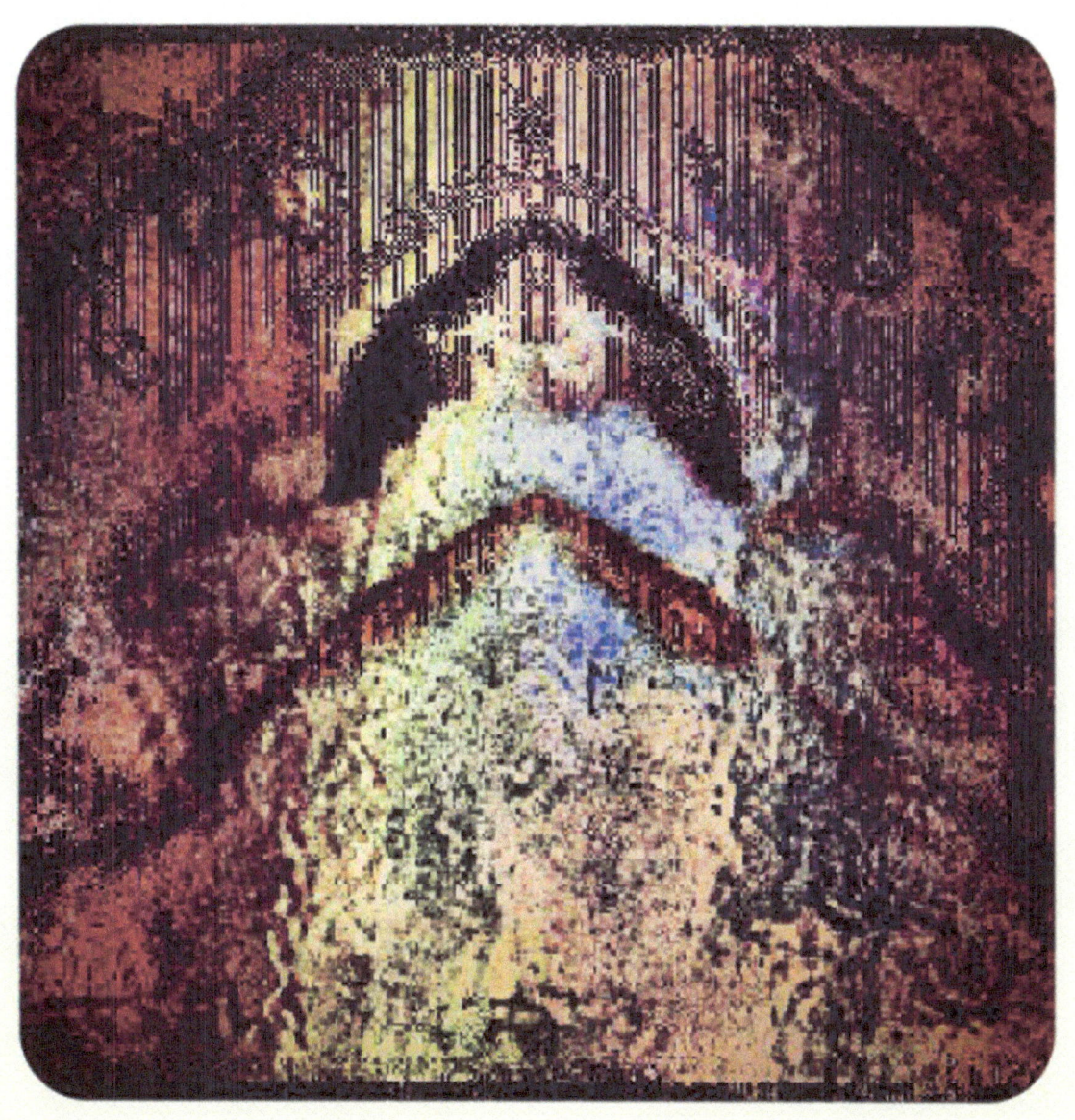

He was worth paying attention to. Just not for the reasons he stated.

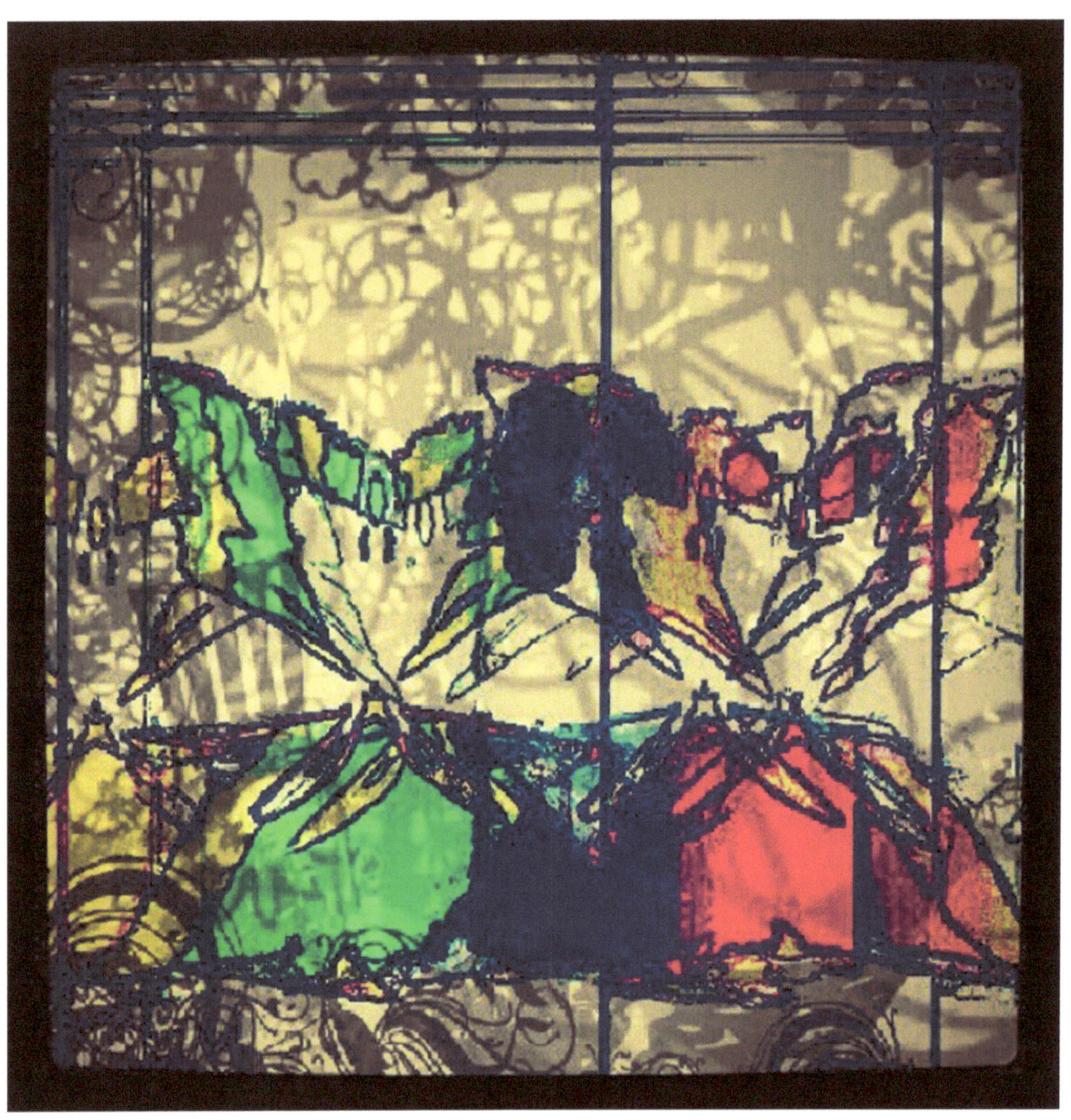

He was bugged by not knowing why she was gone.

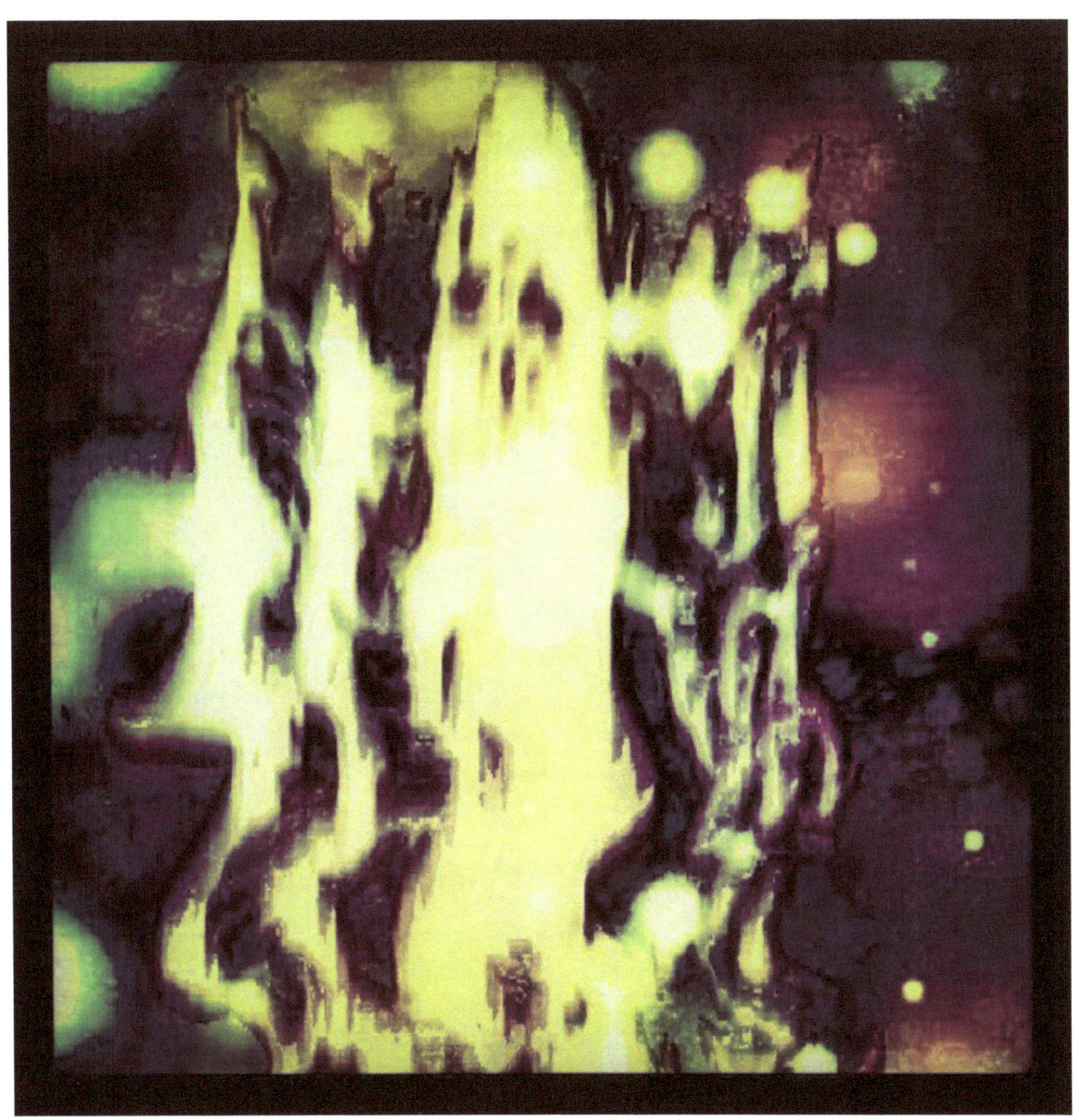

After months of waiting the call came in the middle of the night.

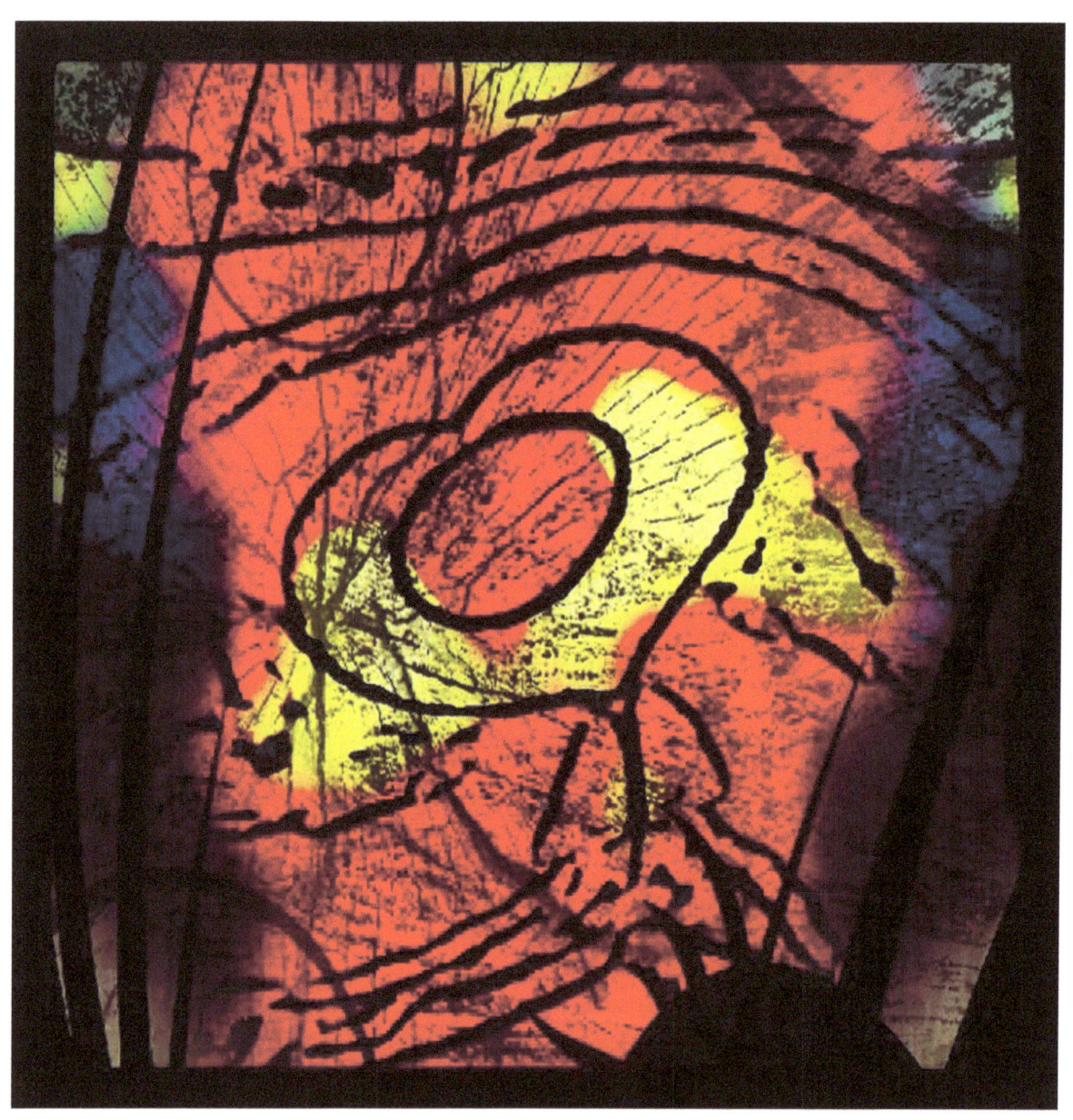

There is no possible way that was what actually happened.

www.ingramcontent.com/pod-product-compliance
Lightning Source LLC
Chambersburg PA
CBHW050802180526
45159CB00004B/1526